COURBET

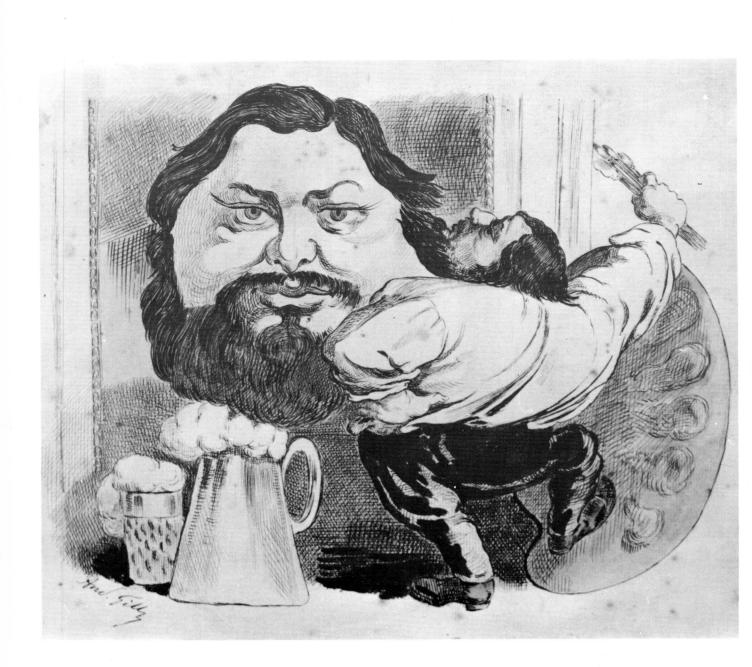

ANTHEA CALLEN

COURBET

JUPITER BOOKS *Publishers*

(frontispiece)
André GILL
Caricature of Courbet
Lithograph published in *La Lune*, 9 June 1867. ORNANS, Musée Gustave Courbet.

This caricature sums up the popular myth which built up around Courbet, based on elements of truth, but begun by the artist himself as a defence, a means for survival: the 'deliberate rustic *patois*, the enormous stomach, the beer, the vanity, the laugh' (Clark, *Image of the People*). As Courbet's friend Jules Vallès wrote of him in 1882: 'So naively vain, so grotesquely eloquent, disorderly and patient, hard-working and thirsty, with the paunch of Silenus, the pride of Jupiter, the beauty of Sesostris: on top of all this as careful of his purse as Sancho, wishing for windmills on his island, and talking of the "million" to be won.'

ACKNOWLEDGEMENTS

I wish firstly to express my gratitude to Alan Bowness, Reader in the History of Art, Courtauld Institute, London, for kindly making available to me prior to publication the French edition of the important centenary exhibition catalogue of Courbet's work, and to the inspired scholarship of Hélène Toussaint and Marie-Thérèse de Forges of the Louvre who prepared it. Janet Holt of the Arts Council of Great Britain gave me much sympathetic assistance during my consultation of the catalogue galleys and photographs. I am also greatly indebted to the challenging reassessment of Courbet's art and ideas in the work of Professor T. J. Clark of the Department of Fine Arts, University of Leeds who has also kindly given me help in tracking down several elusive photographs. I should also like to thank James Barrett, who read a section of the book for me, and Griselda Pollock for her encouragement. My final thanks go to my editor, Robert Oresko, for his patience and hard work in producing the book and to Elizabeth Marr for collecting all the photographs.

Sincere thanks are also due to the following for their help in providing photographs and information and in giving permission to reproduce: Acquavella Galleries, Inc., New York; Arts Council of Great Britain, London; Barber Institute of Fine Arts, University of Birmingham; Bibliothèque Nationale, Paris; Burrell Collection, Glasgow Art Gallery, Glasgow; M. Pierre Chanel, Château de Luneville; Château-Musée de Dieppe, Dieppe; Mr. and Mrs. James S. Deely, New York; Eglise de Saules, Doubs; Gallery Iide, Tokyo; Mr. Adolfo Hauser, Caracas; Hôtel de Ville, Portarlier; Kunsthaus, Zürich; Kunsthalle, Hamburg; Kunstmuseum, Bern; La Société des Amis de Gustave Courbet, Nantes; Leeds City Art Gallery, Leeds; Mauritshuis, The Hague; Metropolitan Museum of Art, New York; Minneapolis Institute of Arts, Minneapolis; Musée d'Arras, Arras; Musée des Beaux-Arts, Besançon; Musée des Beaux-Arts, Caen; Musée des Beaux-Arts, Lille; Musée des Beaux-Arts, Lons-le-Saunier; Musée des Beaux-Arts, Lyons; Musée des Beaux-Arts, Marseilles; Musée des Beaux-Arts, Nantes; Musée du Louvre, Paris; Musée du Petit Palais, Paris; Musée Fabre, Montpellier; Musée Gustave Courbet, Ornans; Musée Jenisch, Vevey; Museum and Art Gallery, Bristol; Museum of Fine Arts, Boston; Museum of Fine Arts, Springfield; National Gallery, London; National Gallery of Art, Washington; Nationalmuseum, Stockholm; Philadelphia Museum of Art, Philadelphia; Rijksmuseum, Amsterdam; Rijkmuseum H. W. Mesdag, The Hague; San Luigi dei Francesci, Rome; Smith College Museum of Art, Northampton, Massachusetts; Staatliche Kunsthalle, Karlsruhe; Toledo Museum of Art, Toledo, Ohio; Mr. Sugihara, Japan; Wadsworth Atheneum, Hartford; Ets. J. E. Bulloz, Paris (Plates 5, 12, 17 and 65); Claude O'Sughrue, Montpellier; Photographie Giraudon, Paris (Plates 22, 37, 46, 51, 71, 79 and 81); Service de Documentation de la Réunion des Musée Nationaux, Paris; Walter Rawlings, London and West Park Studios, Leeds. Finally the publisher would like to thank those collectors who have kindly given permission to reproduce works in their collections, but who have preferred to remain anonymous.

For Henry, Aileen, Neal and Miranda

Unless otherwise specified, all the works reproduced in this book are oil on canvas.

First Published in Great Britain by

JUPITER BOOKS (LONDON) LIMITED, 167 Hermitage Road, London N4 1LZ.

ISBN 0 906379 42 3

Gustave Courbet

I maintain ... that painting is an essentially *concrete* art and can only consist of the representation of *real and existing* things. It is a completely physical language, the words of which consist of all visible objects; an object which is *abstract*, not visible, non-existent, is not within the realm of painting.

Thus wrote Courbet in an open letter to his students in 1861, in which he laid down his beliefs that art cannot be taught. This extract provides one of the crucial keys to the nature of Courbet's Realism, the importance he placed on the representation of what the artist saw and knew and his horror of attempts to recreate past centuries in painting, as was common in contemporary Romanticism and historical genre painting (fig. 1), or to imitate the styles of past masters. Courbet's Realism was based on the concrete, the known; his artistic approach to what he knew was conditioned by the desire for objective truth and sincerity in the recording of reality, a tenet central to the Realist philosophy. Thus the artist's means of rendering the concrete was in terms of verisimilitude, rejecting traditional forms of stylization, idealization of reality or conventionalized schemata, and he turned to his visual experience, to an empirical investigation of reality, as the basis of art.

Significantly, Courbet's Realism grew out of a period in which empirical scientific research and history based upon the study of known facts were themselves emerging. These in turn were products of the growth of democratic ideas in France since the Revolution of 1789, which brought with it a broadened sense of history both past and present, wherein ordinary people and everyday events could be seen as influential in an arena formerly inhabited solely by a ruling élite. It was in this new sense that Courbet can be considered a 'history' painter, for he took it upon himself to record with concentrated accuracy the history of his own

fig. 1 Thomas COUTURE
The Romans of the Decadence
Paris, Musée du Louvre. 466 × 775 cm.

Exhibited at the Salon of 1847, *The Romans of the Decadence* was a much bigger canvas than even Courbet's *Funeral* (Plate II) or *The Artist's Studio* (Plate VIII) and was described by Sloane as 'one of the greatest Salon successes of the century'. It was intended as a 'monumental metaphor for the vices of contemporary society and indeed contains overt references to Louis Philippe's régime' (Nochlin, *Realism*, 1971). The Republican Couture, however, failed in this work to meet the demand for contemporaneity as it was understood by Realists like Courbet, for the meaning of the painting was couched in an historical stylistic guise; it was therefore not simply a contemporary theme which made an artist a Realist. It is useful to compare the academic treatment of the nudes here with the Realist nudes by Courbet.

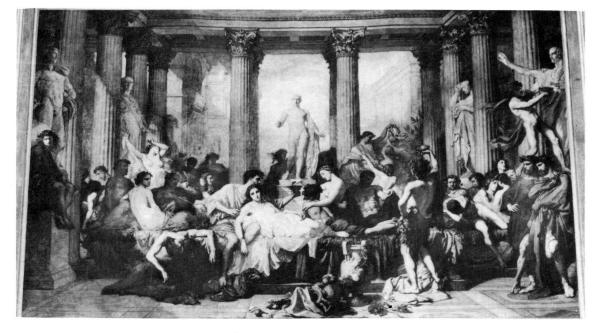

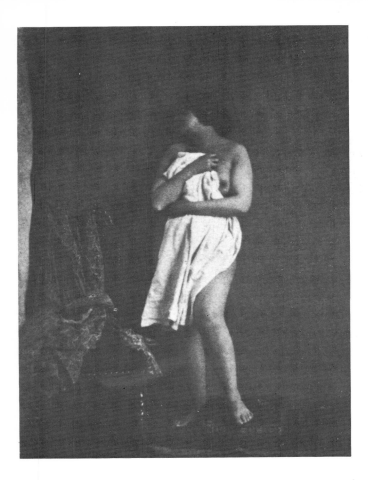

fig. 2 Julien Vallou de VILLENEUVE
Nude Study
Photograph. Paris, Bibliothèque Nationale. No date.

Courbet is known to have worked from photographs in several of his paintings, and Scharf points out that this one was undoubtedly an aid in the treatment of the nude in *The Artist's Studio* (Plate VIII); Courbet was probably introduced to the photographs of Villeneuve by Alfred Bruyas, to whom he wrote in November 1854 asking him to send 'that photograph of the nude woman which I have mentioned to you. She will stand behind the chair in the middle of my picture [*The Artist's Studio*]'. 'The pose, with the drapery held to the breast, is close to that of the painting and the features of the head, the hair style and the characteristic proportions of the body in both painting and photograph are with little doubt those of the same model' (Scharf). It is interesting to note the way in which Courbet turned the figure in his painting, revealing the large hips and buttocks of which he was so fond.

times, the customs and life of contemporary rural France. As he himself stated elsewhere in the 1861 letter:

An epoch can only be reproduced by its own artists, I mean by the artists who lived in it . . . Historical art is by nature contemporary. Each epoch must have its artists who express it and reproduce it for the future.

One of the great myths of Realism was that it was a style-less art, a mirror of reality and nothing more, and

Courbet's concern for verisimilitude and for abandoning schematized modes of representing reality inevitably led him to produce images which are close to our visual experience. Nevertheless, as Linda Nochlin points out in *Realism*, her excellent discussion of the question:

In painting, no matter how honest or hackneyed the artist's vision may be, the visible world must be transformed to accommodate it to the flat surface of the canvas. The artist's perception is therefore inevitably conditioned by the physical properties of paint and linseed oil no less than by his knowledge and technique – even by the choice of brush-strokes – in conveying three-dimensional space and form on to a two-dimensional picture plane.

Realism was attacked by contemporary critics as reducing art to the level of photography which, despite the elements of subjectivity now recognized in this means of representing reality, was seen as purely mechanical. In the sense that Realist painters emphasized the 'descriptive, rather than the imaginative or evaluative' this interpretation was true; however, the equation of Realism in art with its debasement suggests a value judgement on the part of the critics who believed that art should possess a higher, spiritual reality, a universal truth, a notion which was inherent in eighteenth- and nineteenth-century aesthetic theory. An art which *appeared* no different to reality, which was inspired by the mundane and treated it without glorification in all its ugliness, was felt to sacrifice both this higher spirituality and in turn the true function of art; in fact Realism questioned these assumptions. Many artists during this period, including Ingres and Delacroix for instance, used photographs as aids in representing the appearance of reality (fig. 2). They provided cheap and obliging models which were a ready-made tonal and two-dimensional abstraction from the real thing and therefore were already closer to the painted image.

In addition to these elements, an important constituent of Realist art was its subject matter which was essentially contemporary, but was in particular concerned with representing the ordinary people, the peasants and *petit bourgeois*, who had hitherto been considered too low a subject for painting. In the first half of the nineteenth century, the French masses, two-thirds of whom as late as 1871 were still rural, became increasingly powerful as a political force, culminating in the ultimately abortive 1848 Revolution and the short-lived declaration of universal suffrage in March of that year. At the same time, peasantry and workers became gradually more popular as the subject matter for artists and writers, and traditional prejudices against their cultural merit began to break down. In the 1830s George Sand started the first of her rustic novels based on the peasant life and customs in her home region, the Berry; during the 1840s the theme was taken up by popular songwriters such as Courbet's friend Pierre Dupont (Plate 70), who dedicated songs to workers and wrote a celebration of them in his *Chant des*

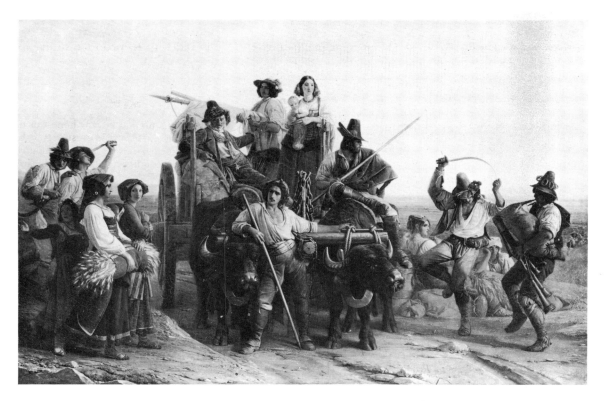

fig. 3 Léopold ROBERT
Arrival of the Harvesters
Paris, Musée du Louvre. 1830. 153 × 227 cm

Robert was one of many artists who presented the Parisian public with a typically Romantic, idyllic vision of the countryside, a notion which Courbet's powerful rural images threatened to dispel, thus causing shock and hostility.

ouvriers. Balzac serialized parts of his powerful novel *Les Paysans* in 1844, and Daumier, using the immediacy of the caricature, was mass-producing his biting lithographic satires of the régime of Louis Philippe, taking up the cause of the common people, but more particularly the urban proletariat. In 1846 the famous historian Jules Michelet published *Le peuple*, a study of the French people in which he applauded the heroism of the peasant and his labour and directed artists to portray the people.

Prior to 1848 images of the peasant were not unknown in French nineteenth-century art, but they were treated as a picturesque genre by such painters as the Leleux brothers, who depicted subjects taken from local provincial customs. Léopold Robert's *Arrival of the Harvesters* of 1830 (fig. 3), although it in fact shows Italian peasants, provides an example of this romanticized approach to peasant subjects and also a contrast against which the uncompromising force of Courbet's work should be measured. To a bourgeois Parisian public brought up on such simplified, sentimental notions of the rural life of France, the complex and brutal social realities found in Courbet's work from 1848 were an unpleasant and unpalatable shock, particularly in the context of contemporary political upheavals. Realism and a choice of common, everday subjects were not new in the history of art; nineteenth-century artists had a strong European tradition of realism to turn to for ideas and inspiration. The work of Caravaggio was already widely acclaimed, while that of the Spanish masters such as Velázquez, Guercino and Zurbarán had been brought to the attention of Parisians by the opening of Louis Philippe's Musée

Espagnol in 1828. It was hardly coincidence that the 1840s was a period of rediscovery and revival of certain Old Masters in this tradition whose work previously had slipped out of fashion; Dutch artists of the seventeenth century were increasing in popularity, while Champfleury, the Realist writer, friend and supporter of Courbet, was by 1848 preparing an article on the French seventeenth-century realist painters, the Le Nain brothers, which first appeared in *Le Journal de l'Aisne* on 26 December 1849. The work of the Italian Primitives was also revalued during this period, as was that of the eighteenth-century French masters, such as Chardin, who regained prominence in artistic taste thanks to the efforts of the influential left-wing art critic Théophile Thoré.

Another art form to attract the attention of avant-garde intellectuals and aesthetes at this time was that of the popular art of the people. Popular prints, simple woodcuts of saints and heroes blocked in with ochres, browns and greens which were sold in the French countryside and drawn by artisan engravers, told a story directly and effectively, because they were intended as means of disseminating information to a broadly illiterate public.

By the 1840s many of Courbet's friends, including his cousin and lifelong friend Max Buchon, were collecting popular prints, both through interest in popular art and a desire to record and salvage a rural culture disappearing in the face of advancing industrialization. Buchon may possibly have provided Courbet with the popular print which he used as the compositional basis for his *St. Nicholas* (Plate 14), and there are many instances of the artist's use of such motifs; he may have hoped that popular imagery would make his art more comprehensible to the common people, though the large scale and the 'high art' approach used by him would seem to indicate that fame and fortune in Paris were of greater importance. Courbet perhaps felt that the vitality of popular prints would regenerate the lifeless decadence of high art, if he could combine the two; certainly, his unique use of these prints gave a simple but striking originality to his compositions, and the stiff, self-conscious, anti-conventionality of his figures owes much to them also.

Realism was a philosophy as well as a style in art and literature; its advocates mostly had left-wing leanings, and it implied a commitment to and concern for contemporary social issues. By painting common subjects *au sérieux*, on a monumental scale traditionally reserved for heroic, biblical or classical themes, Courbet and other Realists asserted the positive value of such issues. Their emphasis on contemporary and common subjects, at that turbulent time in French history, inevitably produced paintings of social relevance, if not 'political' paintings in the narrow sense of the word. Thus, while none of Courbet's paintings, except perhaps *The Artist's Studio* (Plate VIII) and the *Funeral at Ornans* (Plate II) had any overt political or propagandist message, in a social climate where the rural population was mostly disinherited, restless and potentially threatening to the new middle-class political supremacy, an art which portrayed those masses with honesty and directness, unidealized and large, would without doubt have been subversive.

Courbet's family background and origins placed him in an unusual and particularly strong position to understand and represent the class divisions and political uncertainty of rural France. Like his fellow Realist Jean-François Millet, Courbet was born in rural France of peasant stock, but into a family moving upwards in the local hierarchy; Courbet's father Régis owned land and vineyards scattered on the plateau of Flagey and property both in Ornans and Flagey. By the date of Courbet's birth in Ornans on 10 June 1819 his father was already listed as a landowner; the family farmhouse at Flagey was simple and unpretentious, a peasant dwelling, while their house in Ornans, on the rue de la Froidière, was far grander, a bourgeois establishment. Clark observes (*Image of the People*) that Régis Courbet was 'building a bourgeois identity, shuttling between Flagey and Ornans, exchanging his smock for his dress-coat and spats.' Riat summed up their class situation: 'bourgeois more than peasant, not so bourgeois that the young man was deprived of the sight of nature, but too little peasant for them to think of anything else besides a career in the liberal professions for their son.' Courbet was to have trained in law. Régis Courbet appeared regularly in Courbet's work; in the *Funeral* (Plate II) he was shown as a bourgeois, dressed in top-hat and spats, while in *Peasants Returning from the Fair* (Plate 37) he was seen in his peasant's smock and stove-pipe hat. An understanding of the class divisions in rural France, their appearance in Courbet's subject matter and the subsequent impact of his paintings on the audiences in Paris are central to any study of Courbet's art. The idyllic myth of the countryside dear to the Parisians did not include the existence of a hierarchical class structure and a rural bourgeoisie, and the political implications of these complexities were not ones the urban society cared to recognize. Courbet's enormous post-1848 Realist works raised these issues, and thus prevented the urban middle classes ignoring the political crisis in rural France.

Having gained some insight into the nature of Courbet's Realism, it is important to look at the ways in which he arrived at this, his mature style, and to analyze its origins and constituent elements. One myth which has grown up around Courbet, and which he and his supporters fostered, was the notion that he had had no formal training in art; in fact the whole of the 1840s was the period which Courbet devoted to his apprenticeship in painting. Certainly his education did not follow the traditional, formal lines of the aspiring academic painter of the period, with several years at the Ecole des Beaux-Arts and in a private painting studio under a recognized master, working towards the Prix de Rome; but in terms of thoroughness and concentrated study, Courbet's training would have been hard to better. In 1855 he spoke of the reasons behind it:

I simply wanted to draw forth from a complete acquaintance with tradition the reasoned and independent consciousness of my own individuality. To know in order to be able to create, that was my idea. To be in a position to translate the customs, the ideas, the appearance of my epoch, according to my own estimation.

When Courbet stressed that art was 'nothing but the talent issuing from [the artist's] own inspiration and his own studies of tradition' he acknowledged the importance of his own tireless studies of the Old Masters; he had particular notions of an ideal form of artistic training, of which he wrote in 1861, indicating his preference for a collaborative training reminiscent, he felt, of the communal studios of the Renaissance. He believed the master-pupil relation destructive of the

artist's individuality, while collaboration left 'to each person the complete control of his individuality, the full liberty of his own expression in the application of this method' by which, in Courbet's opinion, one became a painter. The emphasis on artistic individuality was a concept of particular importance in nineteenth-century art.

Courbet's insistence on the study of the Old Masters as the sole source of his training was intentionally deceptive; the myth of the self-taught artist was important to him and set him apart from his more traditional contemporaries at a time when the artist's formal training was long and rigorous. It was a myth peculiar to the nineteenth century and established a tradition in itself, followed by later artists such as Claude Monet, who took rebellious pride in their 'self-made man' independence. For Courbet, the reality was more prosaic; he began his artistic education with painting classes from the man who initiated art teaching in Ornans in 1833. This master was Père Baud (or Beau), a former pupil of Gros who possessed several copies he had made in that master's studio; Baud was of lasting importance to Courbet in his emphasis on the need to work directly from nature, an approach which was central to Courbet's Realism. From 1837 Courbet diligently attended the studio of the artist Flajoulet, who was said to have been a pupil of Jacques-Louis David and who was a great admirer of classical and Renaissance art. Under his direction Courbet made numerous studies from the model, while at the same time furthering his own interest in landscape painting. It was at this period that he made his first experiments in print-making, producing four lithographic vignettes for his cousin Max Buchon's first volume of *Essais poétiques* which appeared in Besançon in 1839. Thus, before Courbet left his home town in that same year he had already spent five or six years in organized studio art training.

It was in autumn of 1839, not in 1840 as has traditionally been thought, that Courbet left Ornans for Paris, to continue more seriously his artistic education; this was a traditional pattern, several years in a local art class followed by a move to Paris, usually to try to enter the Ecole des Beaux-Arts. Courbet differed in that he seems never to have wished to go to the Ecole. By December 1839 he was a regular student at the *atelier* of an obscure painter, M. Steuben, and by June of the following year was referring, in dutiful letters to his family, to this artist as his master. Courbet was kept an eye on in Paris by his cousin Julien-François Oudot, the nephew of his maternal grandfather Jean-Antoine Oudot and a professor of law at the Ecole de Droit; while he did not oppose Courbet's artistic leanings, Julien-François nevertheless feared that his cousin was not getting an adequate foundation in the *métier*. He wrote to Courbet's parents in November 1842, questioning whether he was taking the

best route to make good progress. 'Is he correct in wishing to succeed by his own hard work and without the lessons of a master? I am rather doubtful, but he is convinced of it: it is courageous on his part.' This letter suggests familial anxiety at the unconventionality of Courbet's approach and implies that by this date, late 1842, Courbet had left the studio of Steuben to undertake his own education. But he continued frequenting the open studios, where a student could work freely from the model without the constraint of a teacher; in 1844–45 he worked under the guidance of Auguste Hesse, master of Adolphe Marlet his friend from the Franche-Comté. Most importantly, however, he began making copies from and studying the Old Masters in the Louvre and the Musée Espagnol and the work of his contemporaries displayed in the Luxembourg, with the encouragement of his friends Francis Wey and François Bonvin, himself a budding Realist painter. His recollection in 1855, 'I have studied, outside of any system and without prejudice, the art of the ancients and the moderns' was therefore a half-truth. Courbet's artistic apprenticeship thus consisted of several years of formal studio training in both Ornans and Paris, backed up by a thorough study of past masters; the latter gave the student insight not only into the masters' style and compositional formulæ but also involved an analysis of their painting technique and palette.

As Tim Clark argues so forcibly in *Image of the People*, Courbet's education in Paris was far broader than a discussion of his artistic apprenticeship alone implies, for, under the guise of what has become another myth of Courbet, the image of him as a country bumpkin, a conceited semi-literate who had nothing but a technique and an eye, Courbet set out to learn from his contemporaries. This myth, this persona, which has taken on the appearance of truth through the dishonest and self-defensive later writings of an embittered Champfleury, was constructed by the artist as a means both to survive and to gain access to the avant-garde artistic circle of Parisian intellectuals and philosophers. A letter to Francis Wey in 1850 provides the vital clue.

In our oh-so-civilized society it is necessary for me to lead the life of a savage; I must free myself even from governments. My sympathies are with the people, I must speak to them directly, take my science from them, and they must provide me with a living. To do that I have just set out on the great, independent, vagabond life of the Bohemian.

It seems that Courbet played the rustic savage in order not to lose his peasant identity in the sophisticated confusion of Paris; he wanted to avoid becoming a bourgeois while still having access to the knowledge available only to the bourgeoisie. With the semi-autobiographical bohemian image of the vagabond Fourierist prophet Jean Journet in his mind (fig. 4) Courbet created his own Parisian life-style.

Courbet's bohemia, as Tim Clark points out, was not

fig. 4 Gustave COURBET
The Apostle Jean Journet
Paris, Bibliothèque Nationale. 1850.
Lithograph 17 × 24 cm.

Courbet depicted the Fourierist prophet 'setting out for the conquest of Universal Harmony', much as he saw himself as having 'just set out on the great, independent, vagabond life of the Bohemian'. This was Courbet's last great bohemian portrait, the oil version of which, now lost, he exhibited at the Salon of 1850-51; it was based on the legend of the Wandering Jew, a common theme for popular prints (fig. 5). His important self-portrait *The Meeting* (Plate V) was also based on the image of the Wandering Jew, the social outcast and outsider.

the romantic life-style portrayed in Henry Murger's *Scènes de la vie de Bohème*; in the 1840s and 1850s bohemia was 'an unassimilated class, wretchedly poor, obdurately anti-bourgeois', in Paris it was 'a real locus of dissent' a 'confused, indigent, shifting population' which belonged more to the *classes dangereuses* than the bourgeois student population of the Latin quarter. It was a 'life-style *and* a social situation'. Thus for Courbet to 'set out on the great, independent, vagabond life of the Bohemian' was to avoid identifying himself with the bourgeoisie, and to find a positive alternative. If Courbet's 'homme sauvage' gave him detachment from the 'stifling, chaotic agreement which prevailed among

the members of the Parisian avant-garde; openness to ideas and experiences which were profoundly alien to that world and its coteries', then his true naïvety enabled him to dominate it. As Max Buchon recorded:

Courbet's greatest advantage, in the midst of the chaos surrounding him, is undoubtedly his rich spontaneity...I have mentioned Courbet's spontaneity. Let me now mention the sureness of his glance, the subtlety of his moral sense, the ease with which he follows and often dominates the movement of current sane ideas, helped only by his great intuitive power. Courbet has never had anything in the way of instruments of education and study except his magnificent vision, and that has been quite enough.

Courbet frequented the bohemian centres of Paris, the Brasserie Andler and the Cénacle du Bas-Meudon, talking, drinking, carousing with his sophisticated Parisian friends, who included Baudelaire, Marc Trapadoux, the bohemian and mystic whom Courbet painted examining a book of prints in 1848–49 (private collection), Champfleury, the worker-poets Pierre Dupont and Gustave Mathieu, the artist-philosopher Paul Chenevard, the right-wing philosopher and translator of Hegel's *Logic*, Jean Wallon and, occasionally, the socialist philosopher Proudhon. His world in Paris was evoked by Boudin in his journal for 1859:

...it was monstrously noisy. Heads whirled feverishly, reason tottered. Courbet proclaimed his creed, needless to say in a totally unintelligible manner...We sang, shouted and bellowed for so long that dawn found us with our glasses still in our hands. On our way home we made a din in the street, it was all most undignified ...This morning our heads felt dull.

In 1848 the artist made a drawing, now apparently lost but reproduced in de Forges as no. 43, showing himself youthful and dressed in the style of an elegant dandy-bohemian, with his large bearded friend Marc Trapadoux in the Brasserie Andler. This gives visual expression to his bohemian style. In his oil self-portrait *Man with a Pipe* (Plate 18) the bohemian image is closer to the casually dressed vagabond than to the stylish dandy, while in the drawn version (Plate 19) his affected pose contrasts with the firm treatment of concrete details, as in the clothes.

This formative period inspired other works reflecting Courbet's bohemia, his *Portrait of Baudelaire*, himself a dedicated bohemian (Plate 15), the *Portrait of Marc Trapadoux Examining a Book of Prints* and the final, crucial image of *Jean Journet* in 1850, a lithograph (fig. 4) and a lost oil painting of this Fourierist 'setting out for the conquest of Universal Harmony', which Courbet based on a popular print of the legend of the Wandering Jew (fig. 5). Courbet later used the same print as the source of his own definitive self-portrait in *The Meeting* of 1854 (Plate V), which Clark sees as an important link between the two men, suggesting that Courbet turned to Journet as a model for his own developing personality. Courbet's numerous self-portraits from the 1840s have been seen as evidence of the vanity of the man; in fact they tell us more interesting things about him. He sold almost nothing in his first ten years, his

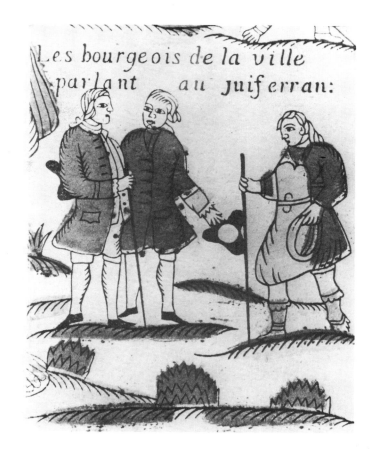

fig. 5 Anonymous (Norman Workshop, possibly Rouen)
The Bourgeois of the Town Talking to the Wandering Jew, detail from *The Legend of the Wandering Jew*

Courbet's use of this image to structure the composition of *The Meeting* (Plate V) is quite clear, although his minor adjustments to the print made his oil a complex and confident statement. Courbet turned his own figure into the picture to confront the bourgeois, Bruyas, strengthening what in the print was a weaker stance. The servant, Calas, on the far left, was given equal attention and weight in the oil, but a deferential, subservient gesture points up the class differences; the two men on the left in the print are both bourgeois. Although based on the popular print, *The Meeting* shows scrupulous observation in its rendering of nature and details.

formative period, and was reliant upon his family. Thus, for a struggling young artist, as Courbet then was, the cheapest model was himself or his friends. His early, dutiful portraits of his family (he returned almost every year to Ornans) are unadventurous compared to those of himself, in which he felt free to experiment and to search for his identity both as an artist and as a man. Large numbers of self-portraits were a particularly nineteenth-century phenomenon and can be seen in part as reflecting the new anxiety of the age created by rapid social change, the rise in value of the physical above the spiritual and the consequent psychological search for a sense of self. Self-portraiture may also have

reflected a new pride in the profession and in the artist himself as a result of a comparative independence from the traditional patrons of art, the Church, the state and the nobility, and of having to struggle for survival. Courbet's numerous self-portraits can be studied as representative of his artistic evolution during the 1840s.

In one of his earliest self-portraits (Plate 4) Courbet reinterpreted a traditional pose found in seventeenth-century portraiture in France and Holland, in which the sitter leans forward on a windowsill or balustrade, seeming to project out of the picture space; this youthful work is thought to have been the first idea for a self-portrait of c. 1844, *Courbet with a Black Dog* (Plate 8) in which the landscape setting is reminiscent of English eighteenth-century portraiture. In both these works the artist showed his early leanings toward Romanticism, more particularly in the later one in which his flowing locks and tilted face are shaded by a floppy black hat, and he sports elegant clothes of a dandified character. The outdoor setting shows Courbet's early involvement in representing his native countryside around Ornans, an allegiance which developed during his years in Paris to become a central element in his major Realist works. The book seen at his side may be a sketch-book or may have been included as a symbol of the desire for knowledge which directed his way of life at this period. The most blatantly Romantic of his early self-portraits, however, was undoubtedly *The Sculptor* (Plate 10), an unsuccessful, uncomfortable painting in troubadour style, in which Courbet depicted himself in medieval costume, holding a mallet and chisel. The tightly drawn figure, lifeless in a contorted pose, clashes awkwardly with its landscape setting. This is diluted Romantic genre painting of the 1840s at its worst, sentimental in feeling and unhappily Ingresque in its figure drawing; it was not a compromise the artist chose to repeat. A more or less contemporary painting, the *Game of Draughts* (Plate 11), with a caricatural self-portrait of the artist as a Mephistophelean figure with a small, pointed beard, is nevertheless a more convincing painting, with its careful observation of Courbet's Paris studio interior contrasting with the overall pastiche of Dutch and Flemish seventeenth-century gaming scenes.

Courbet's self-portrait as *The Desperate Man* (Plate 7) shows the artist searching himself for extremes of emotion, producing a dramatic close-up image, his anguished face lunging forward towards the spectator. As Toussaint points out (*Courbet* 1977–78), there may have been other impulses behind the painting, which is of particular significance in view of Courbet's artistic apprenticeship at this period. This startling physiognomy may have its origins in the *têtes d'expression*, engravings of human faces expressing varied emotions which were used for teaching in art schools and studios. This would therefore place this self-portrait in the category of an academic study, albeit a rather personal

one. In several of his self-portraits of the 1840s Courbet produced something of a diary of his amorous life, a youthful celebration of his conquests, showing himself in the image of the great lover. *The Large Oak* (Plate 6) is one of the earliest of these, while the series of three sets of 'happy lovers' (Plate 12 and de Forges nos. 29 and 31), all also set in landscapes, show far greater drama and mastery in the strength of composition and in the power with which the figures fill the canvas.

A drawing, *Country Siesta* (Plate 32), showing Courbet possibly with Justine, a lover, or Virginie Binet, the lover with whom he had his longest affair, has been dated by Toussaint (*Courbet* 1977–78) to after 1849, with the added proviso that it may have been produced at the same time that the painted version of the same composition (see x-ray, fig. 6) was reworked by Courbet into *The Wounded Man* in 1854 (Plate 33), when Virginie and their son finally separated from Courbet. A comparison of the *Country Siesta* with Courbet's drawing of 1855 for *Young Ladies on the Banks of the Seine* (Lyons, Musée des Beaux-Arts, de Forges, no. 8) or even with his confident self-portrait drawing of c. 1849 (Plate 19) would indicate that a dating for the *Country Siesta* of 1849 or after is unlikely; the awkward handling of both material and composition in *Country Siesta* and the anatomical difficulties in rendering the man's right arm in particular would seem, if compared to the right arm in the *Little Portrait* of 1842 (Plate 4), to confirm the earlier dating of 1840–44 proposed by de Forges (no. 7). The evolution of *The Wounded Man* is of exceptional interest for the light it throws on Courbet's methods; Delbourgo and Faillant published the x-ray made by the Laboratoire de Recherches des Musées Nationaux de France (fig. 6), which reveals that underneath the present picture lie two earlier works. The one immediately below the present surface relates compositionally to the *Country Siesta* drawing, which may have been a preparatory study; the date 1840–44 suggested for the drawing would thus indicate a date of c. 1845 or possibly later for the obliterated painting. This date would coincide with Courbet's period of avid interest around 1844–45 in painting himself with lovers.

The first painting which Courbet executed on this canvas poses greater problems and is thus of even more interest than has been suspected. Delbourgo and Faillant describe the initial working that was visible in the x-ray.

From the first composition one can only recognise the head of a woman; her coiffure with a broad flat bandeau recalls the female figures drawn by Courbet in his youth ... Worked in light colours of high atomic mass, the face remains precise on the x-ray film, although covered by dark earth colours for the present composition, it went unsuspected up until the present day.

The woman's head thus described is visible in the x-ray (fig. 6), in the centre of the composition, beside the head of Courbet and his lover from the second painting. However, upon closer examination of this x-ray, further

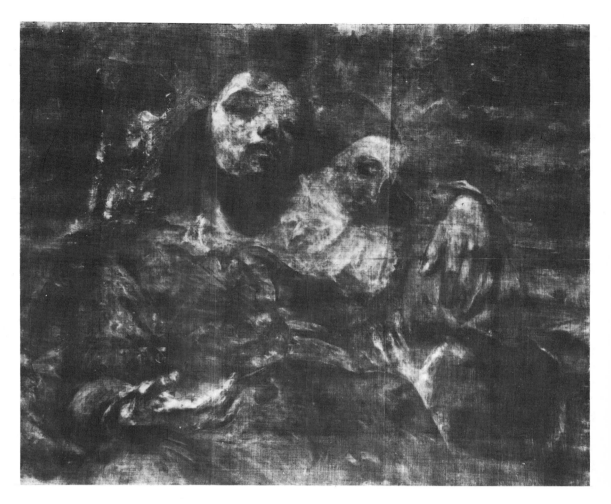

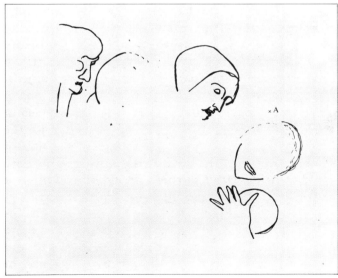

fig. 6 Gustave COURBET
The Wounded Man
X-ray photograph of Plate 33. Paris,
Laboratoire de Recherches des Musées
Nationaux de France.

This x-ray reveals the two paintings which lie
hidden beneath the present, sombre subject; a
tracing of the main figures in the first compo-
sition can be seen in fig. 7, while the subject of
the second painting was based on a theme
close to that in *Country Siesta* (Plate 32).

fig 7 Gustave COURBET
The Wounded Man
Tracing of the first composition under Plate
33, from the x-ray, fig. 6.

This tracing outlines the chief figures visible in
the x-ray, from Courbet's earliest composition
on that canvas. 'A' marks the spot where a
paint sample was removed for analysis by
Delbourgo and Faillant.

elements of this initial, unidentified painting emerge
(see tracing, fig. 7); this undoubtedly early and
apparently quite important composition in fact con-
tains at least five figures, all clearly discernible. A
strange, perhaps old, gnarled face, looking down and
into the composition, is visible to the far upper left,
while to the immediate left of Courbet's head and neck
appears the outline and blocking-in of part of a second
head. Then comes the third, already identified female

head, gazing down, from the appearance of the half-
closed eyelids, towards the fourth and fifth figures.
Beneath the form of Courbet's drooping left hand can
be distinguished the fourth face, a head in three-
quarters view, tilted over towards her left shoulder; her
ear is visible to the left of Courbet's thumb, while her
mouth and chin can be seen to the left of his forefinger. I
call the figure female by virtue of the soft, heart-shaped
facial form, full mouth and small chin, and because the

fifth visible figure is an infant held in her arms; its small head is clearly visible below her face, as is her hand which in this composition supports the child's head, and in the second composition, related to *Country Siesta*, was changed into the hand of the lover, clutched to her breast.

Thus, the initial composition is clearly a far more complex work than has been thought. It is possible that it represents one of Courbet's many lost or obliterated early copies after the Old Masters; few such works of his survive although he is known to have done many. The artist was well known for his economical re-use of canvases that displeased him or were of no further use. I have not as yet been able to identify the original of which this composition may be a copy, although from the compact grouping of the large-scale figures, their proximity to the picture plane and the apparent shallowness of the pictorial space, it would seem to be in the style of the great seventeenth-century realists such as Caravaggio or even Courbet's Lorraine predecessor Georges de la Tour. The simple and direct treatment apparent in the most clearly visible swathed female head would seem to confirm this hypothesis; the gnarled and presumably male head is evocative of certain heads by Rembrandt. The subject matter implied by the grouping of the figures and the inclusion of a mother and child and what seems to be an old man to the far left would suggest another factor unusual and therefore of particular relevance to Courbet's early development; this may be a religious subject, a nativity or a Virgin and St. Anne theme. The only other known religious painting executed by the artist was his *St. Nicholas* (Plate 14) of 1847 for the Eglise de Saules. If this interpretation of the subject matter is accurate, it implies a wider range of influence on the artist's early work than has been thought.

Confirmation of the Virgin and Child subject is suggested by the chemical paint analysis undertaken by the Service de Chimie of the Laboratoire de Recherches des Musées de France, by Delbourgo and Faillant; a paint sample taken at the position of Courbet's left hand in the second painting (fig. 7, marked 'A') was studied. 'On top of the white canvas ground, a thick layer of light blue paint has been placed first of all; could this be a background of blue sky to the first composition?' Because of the low position of this sample in the composition, the suggestion of a blue sky, although possible, is debatable; could the patch of blue not perhaps represent part of a highlighted portion of the traditional blue robe of the Virgin, which at this point in the picture would have been covering her head? A further possibility for the origins of this subject concerns its possible relationship with the birth of Courbet's unacknowledged son, Désiré Binet, in 1847; Courbet is thought to have included his son in at least two paintings (Plates VII and VIII) and, rather than a copy, this work may be an original composition

celebrating the birth of his son, which would date it to 1847. An argument against this hypothesis, however, is the depiction in the second painting, executed over the first, of Courbet and possibly Virginie Binet together as a pair of lovers.

Courbet's method of re-using old canvases merits further discussion. Some of his paintings have been x-rayed and reveal earlier compositions beneath the existing ones, including *The Man with the Leather Belt* (Plate I) and *A Spanish Lady* (Plate 36). As in the two compositions below *The Wounded Man*, Courbet intelligently exploited existing elements of the earlier compositions when reworking them; the flesh painting of the Virgin's head was an excellent colour foundation for the hand placed over it in the second composition. Part of the face of the swathed central female was taken over in the rendering of the lover on top, as was the second head on the left in the later painting of Courbet's head. The lover's hand was based upon the earlier hand of the Virgin figure; other elements of this kind may be invisible to the x-rays. In both *The Man with the Leather Belt* and *A Spanish Lady*, the portraits underneath were treated in the traditional manner for re-using such a subject, both having been inverted for the second painting. Under *A Spanish Lady* is a fine, half-length portrait of a woman, the other way up, while of particular interest is the reversed portrait beneath *The Man with the Leather Belt*. An x-ray published by Delbourgo and Faillant reveals that Courbet executed this self-portrait over a copy of Titian's *Man with a Glove* (fig. 8), confirming a stylistic link intuited by several art historians. In re-using this canvas Courbet exploited the white collar and shirt-front of the Titian copy as the basis for his own hand, wrist and cuff. The inversion of an earlier portrait when re-using the canvas is a logical step, as the thickest and most heavily worked area would be the face; elsewhere the paint layer would be comparatively thin and therefore easier to work on and less likely to cause cracking or deterioration through excessive paint layers. Another factor in inverting an old portrait, or any other composition, would be the avoidance of the distraction of facing head-on an existing image, if, as was common, no intermediary lay-in were used to cover the original image.

Although few copies by Courbet have survived, it is evident from the stylistic changes in his own compositions that by the mid-1840s he was increasingly turning his attention towards the great realist masters of the seventeenth century, to Rembrandt and Frans Hals, to the Spaniards Velázquez and Zurbarán and to the Bolognese master Guercino. In August 1846 Courbet visited the Low Countries for the first time, spending a few days in Amsterdam and in Belgium; in The Hague he remarked that he saw the most beautiful collections and felt that he had learned more on his short trip than he could have in three years of study. He made a second trip to Belgium with Champfleury the following year,

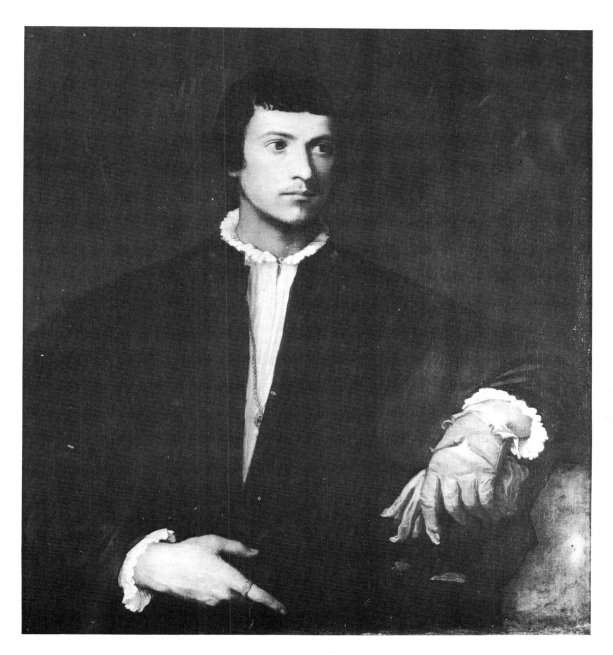

fig. 8 TITIAN
Man with a Glove
Paris, Musée du Louvre. 1520–22. 100 × 89 cm.

and in 1850 he recalled the importance of his impressions on those visits, stating that 'all my sympathies are for the people of the North. I have travelled through Belgium twice and Holland once for my instruction and I hope to return there.' If the influence of Titian and Velázquez dominated his portrait of himself as *The Man with the Leather Belt*, the tide was turning northwards in his *Cellist* (Plate 13), yet another self-portrait, of which Champfleury wrote when it appeared in the open Salon of 1848, where Courbet exhibited ten works:

Courbet . . . sent some very remarkable and very diverse paintings, of which I am the first to talk. Nourished by Rembrandt and Ribera, this youth has captured such solid qualities that he exaggerated his ancestors a little. One could place his *Man with the Cello* in the Spanish Museum, where it would remain proud and tranquil, without fear of the paintings by Velázquez and Murillo.

While Champfleury placed almost greater emphasis on the Spanish masters than on Rembrandt, Clark

Delbourgo and Faillant have published an x-ray of Courbet's *Man with the Leather Belt* (Plate I) which reveals an inverted copy after this Titian painting beneath it; several art historians had previously suggested a stylistic link with the work of Titian in Courbet's self-portrait, although the artist himself maintained that it had been inspired by Velázquez and the Spanish Old Masters, as indeed had many of his early self-portraits.

suggests the links with the Dutch master are greater:

The Cellist is Rembrandt confused by the same concern for elaborate posing and spatial arrangement – undecided whether to set the figure in a dissolving chiaroscuro or against a background which presses it to the canvas surface. It tries for compromise, and straightaway the drawing disintegrates and the old contortions appear.

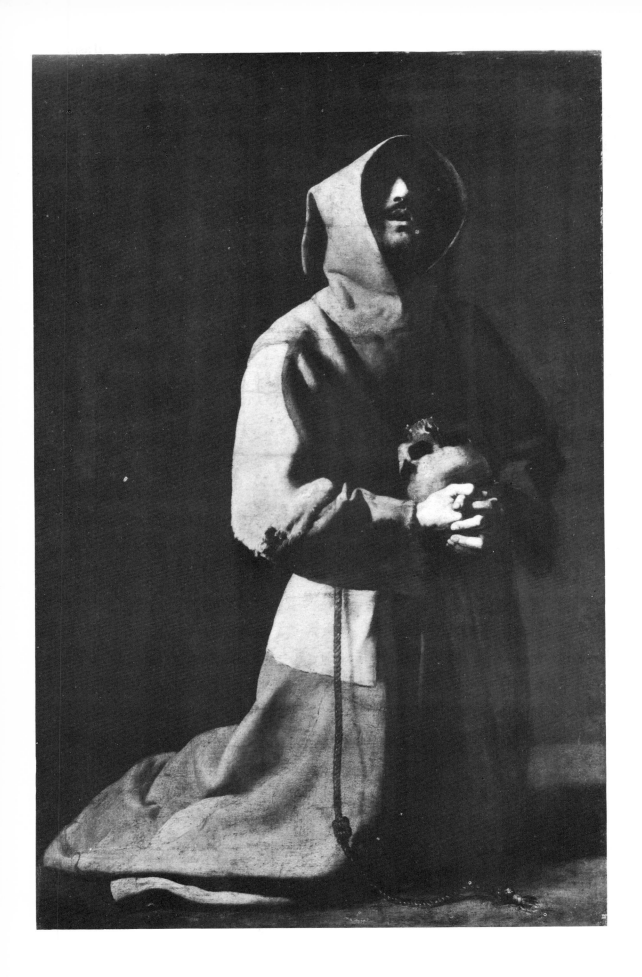

16

It is significant that Champfleury mentioned Courbet's 'diversity' in his Salon critique; while it is true that Courbet's Salon exhibit included works from at least as early as 1844 (the jury had been suppressed in 1848 and all works accepted), nevertheless Courbet's work of this period was highly eclectic, reflecting the widely varied sources in his search for an individual style and subject matter. *The Cellist* was also admired by Prosper Haussard, the critic for the influential *Le National*, who likened Courbet's skill in handling and chiaroscuro to that of both Caravaggio and Rembrandt. Another portrait, this time of Baudelaire (Plate 15) and probably from around the same date as *The Cellist*, shows that Courbet had observed the virtuoso painting techniques of Frans Hals, whose work he saw on his trips to the Low Countries. Although this portrait is unfinished, in the rendering of the flesh passages, in the broad brushwork of the hand and the slabs of unmixed vermilion and bright highlights on the writer's face, it is clear that Courbet was making direct and effective quotations from the Dutch master.

The impact of Courbet's study of the Spanish masters, in particular of Zurbarán, comes through most clearly at this date in his *St. Nicholas Reviving the Little Children* (Plate 14). Louis Philippe's Musée Espagnol included such works as Zurbarán's powerful *St. Francis with a Skull* (fig. 9), from which Courbet copied more than anything else the 'sheer butality, the unembarassed emotion of the paintings, and of the painters' own legendary lives' (Clark, *Image of the People*). Courbet's *St. Nicholas*, his largest composition to this date, is of especial importance in the analysis of the development of the artist's style and imagery during the 1840s; in this unresolved .painting he tried for the first time to structure his overall design on the basis of a popular print, a late eighteenth-century version of the same subject, *Canticle to St. Nicholas*, from the Jean Tissot workshop in Besançon (private collection, reproduced in *Image of the People* as plate 19). Although the painting finally owed more to the Spanish master in the rendering of space and form than to the flattened, stylized 'cut-out' simplicity of the popular print, it

fig. 9 Francisco ZURBARÁN
St. Francis with a Skull
London, National Gallery. c. 1639.
152 × 99 cm.

This painting was one of the collection of Spanish paintings which formed the Musée Espagnol of Louis Philippe, opened in Paris in 1828; the collection had a marked effect on many contemporary French Romantic artists and was also influential in bringing the brutal power of seventeenth-century Spanish realism to the notice of younger artists such as Courbet. The direct influence of Zurbarán can be seen in his *St. Nicholas Reviving the Little Children* (Plate 14), in the modelling and treatment of light and shade on the figure of St. Nicholas.

nevertheless marked the beginning of a crucial aspect of Courbet's work, not only in its formal relevance but also in terms of Courbet's stated aim to 'draw his science from the people', among other factors to incorporate elements of their own popular art tradition into his painting.

We also find the influence of Spanish art in Courbet's self-portrait *The Man with the Pipe* (Plate 18), one of the most vigorously successful of the artist's studies of himself from this early period. Although the handling of the flesh still owes something to Hals, in overall treatment the greatest debt was to Guercino, as was noted by the Salon critics of 1851. The subject of the smoker had its origins in Flemish seventeenth-century art, in Craesbeck's *Smoker* in the Louvre which was then thought to be by the Flemish artist Adriaen Brouwer. Compared to the Romantic *Man with the Leather Belt* (Plate I) this is an overtly bohemian image of the artist, self-consciously posed and flamboyant; Courbet wrote a telling description of it for Bruyas in 1854, when the collector purchased it: 'the portrait of a fanatic, an ascetic...the portrait of a man disillusioned with the foolishness that made up his education and who searches for principles of his own to hang on to' (Borel I). This was the Courbet of the 1840s, a dedicated fanatic searching for individual principles, searching for a personal subject matter and for the means, both technically and stylistically, to communicate them; by 1849 he had found them all.

II

M. G. Courbet, who has come to Paris from a village in the provinces, promised himself that he would be a painter and be his own master. He has kept his word. After ten years of studying, of painful effort and hesitation, after ten years of hardship, poverty and obscurity, at the very moment when he had run out of money and was ready to give up, here he is – a painter, and very nearly a master already... These hard beginnings, this solitary apprenticeship, and the long trials endured by M. Courbet, are all visible in his paintings, which are marked by a certain sombre and concentrated force, by a sadness of expression and a certain savagery in their style. His landscapes...are no more than sketches; yet they have this same grave and penetrating character.
Prosper Haussard, 'Salon [of 1849]', *Le National*, August 1849.

At the Salon of 1849 Courbet's exhibit included *After Dinner at Ornans* (Plate 17), to which the critics reacted favourably; although Realism was at that date not considered respectable, neither was it regarded as a dangerous trend. The artist was awarded a second-class Gold Medal, which freed him from the necessity to submit his work to the Salon jury, making him *hors concours*; this proved fortunate in view of the hostile reaction to his later paintings. The work was bought by the state for 3000 francs and, although intended for the Luxembourg, which would have sealed Courbet's reputation, was, after some hesitation, sent instead to

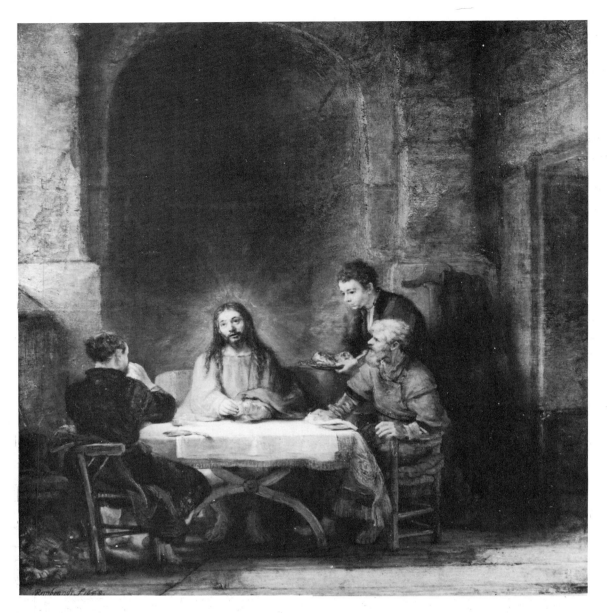

fig. 10 REMBRANDT van Rijn
Supper at Emmaus
Paris, Musée du Louvre. 1648. Oil on panel
68 × 65 cm.

Despite the difference in atmosphere and the scale of figures in relation to overall format by comparison with Courbet's *After Dinner* (Plate 17), this painting is one of those most frequently cited as a source for Courbet's picture; although Courbet regularly quoted from Rembrandt, particularly during the 1840s, the *Supper at Emmaus* is not an example of the often close connections with this Dutch seventeenth-century master. Courbet would have known the Rembrandt painting, and there may be a link in his choice of pose for the seated figure on the far left of *After Dinner*, the artist's father.

Lille. *After Dinner* was the first major work in which Courbet began to resolve the complex directions of his work of the 1840s. Despite the number of borrowings from the Old Masters, these were thoroughly assimilated by the artist, and the final product was essentially personal and original. In a muted form, *After Dinner* also contained the germ of Courbet's mature Realist style; large scale, 'common' rural subject matter, the description of a particular event, careful verisimilitude, a direct and apparently simple composition and powerful craftsmanship. The novel combination of rural subject and large scale did not pass unnoticed by the critics, one of whom, Lagenevais, wrote in *La Revue des Deux Mondes*, 'he should show them to us, in the Flemish manner, through the wrong end of a telescope, so that they become poetic as they recede into the distance'. This statement highlights a major difference between the Realism of Courbet and that of his precursors, the large, uncompromising and non-anecdotal scale of his images of ordinary life.

After Dinner is imposing in size, over six feet high by nearly eight and one-half feet wide, and the figures are life-size. The deceptively simple compositional grouping is an unusual one; major paintings have been variously cited as sources for it, Rembrandt's *Supper at Emmaus* (fig. 10), Velázquez's *Supper at Emmaus* (fig. 11),

Caravaggio's *Calling of St. Matthew* (fig. 12) and Louis Le Nain's *Peasant Meal* (fig. 13). All four show figures grouped around a table, and all but the Le Nain include figures viewed from the behind, on the right of the composition in the Velázquez and on the left in the Rembrandt. The composition of the Caravaggio painting is closest to Courbet's, with a central figure with his back towards the spectator. In the Velázquez and the Rembrandt the side placement of these figures assures a circular, compact group to which the spectator has direct access through the resultant gap between the figures in the foreground.

In both the painting by Courbet and that by Caravaggio the composition is less straightforward; in the Caravaggio it is divided into two sections horizontally, with a compact group on the left, two standing figures on the right and the seated figure with his back to us linking the two halves. Toussaint (*Courbet* 1977–78) points out compositional changes in the Courbet, revealed by x-ray, reinforcing the connection with the Caravaggio. However, there is no such division in Courbet's composition, in which the figures are placed almost frieze-like at regular intervals across the picture surface, not divided in two, nor with any sense

of a compact grouping. The centre foreground is dominated by the back of the Marlet brother and the back of the chair in which he is sitting, both of which are turned brusquely against the spectator excluding him from the composition. *After Dinner* was made more complex by the even balance of figures placed

fig. 11 Diego VELÁZQUEZ
Supper at Emmaus
New York, Metropolitan Museum of Art (bequest of Benjamin Altman). 1628–29.
123 × 133 cm.

A copy of this painting was in the Musée Espagnol in Paris, and it was undoubtedly one of the Old Master paintings in Courbet's mind when he began working on *After Dinner at Ornans* (Plate 17); Clark notes in *Image of the People*: 'From Velasquez and the Spanish school in general he took something of the treatment of the still-life on the table or the bowl upon the floor, some of the details of... [Cuénot's] pose and expression, and something of the compressed space between the two right-hand figures; from Zurbarán perhaps something of the harsh but even light on Marlet's face and figure: compare his clothing with the tattered cassock of *St. Francis with a Skull* [fig. 9].'

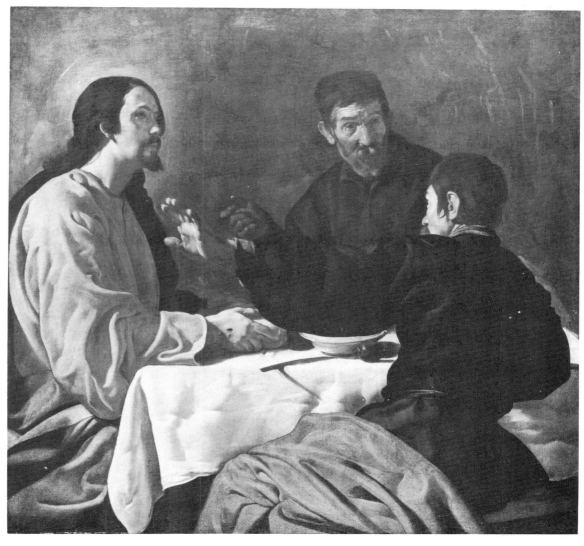

alternately in the foreground and background, setting up a rhythm for the eye across the canvas in and out of the shallow pictorial space. While Caravaggio's composition is complex and dynamic, Courbet's sombre interpretation produced an original format and rhythm which looked forward to the greatest paintings of his career rather than back at the past. The extent to which the spectactor is excluded from this painting, both through its composition and its narrow pictorial space, is perhaps a prophetic visual metaphor for one of the symbolic themes of Courbet's art, which appears in concrete form in *The Artist's Studio* of 1855 (Plate VIII), his celebration of the act of painting in itself. In *After*

fig. 12 CARAVAGGIO
The Calling of St. Matthew
Rome, San Luigi dei Francesci. c. 1601.
322 × 340 cm.

Toussaint (in *Courbet* 1977–78) points out the importance of this work, which may have been known to Courbet in the form of an engraving, in his conception of *After Dinner at Ornans* (Plate 17); but Courbet's direct and simple disposition of his four figures at regular intervals across a shallow pictorial space moved far away from this complex, though possible source of inspiration.

Dinner the spectator can but look on, and thus the artist reinforced the autonomous reality of the painted image.

Louis Le Nain's *Peasant Meal* was more a general prototype than a direct source of compositional inspiration to Courbet's *After Dinner*. Champfleury was instrumental in reviving interest in the works of the seventeenth-century Le Nain brothers, and Courbet could have seen at least two of their works, brought up from the Louvre cellars in 1848 in response to their popular themes, by the time he began his canvas late that year. Toussaint states (*Courbet* 1977–78) that the Louvre had only *The Adoration of the Shepherds* and *The Forge* at that date, while Clark, indicating that it also owned *The Peasant Family*, suggests further that the treatment of space in this painting was more important to Courbet than the more conventional grouping of the *Peasant Meal* (fig. 13), then probably in the La Caze collection in Paris, which Courbet may have visited. The *Peasant Meal* is, however, closer to the detail of Courbet's *After Dinner*. 'From the Le Nains he took a certain gravity of tone and a ruthless simplicity of arrangement, with the figures placed casually across the canvas surface, each one "added" to the next without any transitions of gesture or linking of pose.'

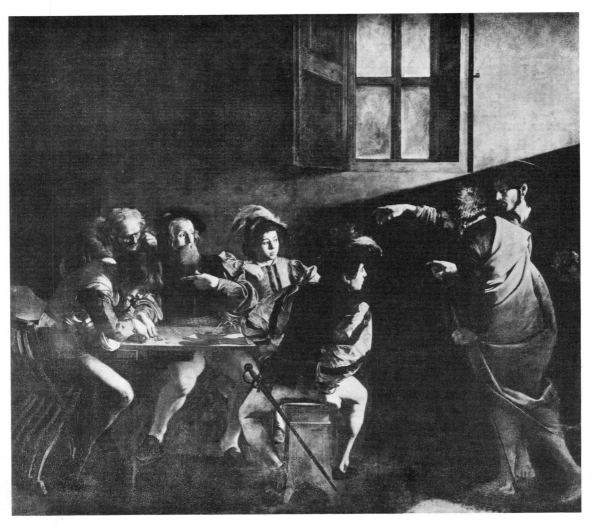

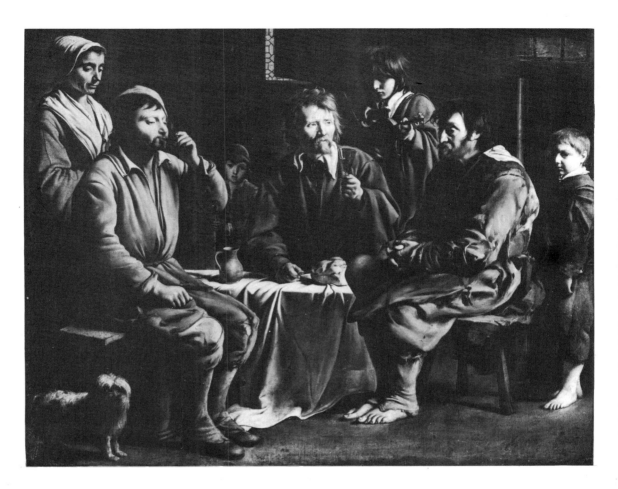

The use of light, though far less dramatic, and 'narrative', owes something to the Caravaggio *St. Matthew*, while the treatment, particularly in the still-life motifs, is a reminder of Courbet's familiarity with the Spanish masters. The final result with this picture, however, is that of a unified, personal whole.

Once Courbet had discovered his subject matter, his problem with tradition and the conflicts evident in his work of the previous ten years all fell into place and resolved themselves in a matter of months to produce his mature Realist style. In October 1849 Courbet returned to Ornans, to the source of his new subject matter, to begin work on a series of three major paintings for the next Salon. These epic peasant and rural canvases were *The Stonebreakers* (Plate 21), the *Funeral at Ornans* (Plate II) and the *Peasants of Flagey Returning from the Fair* (Plate 37). As Linda Nochlin stresses in her discussion of the heroism of labour, it was only after the 1848 Revolution, when the subjects of the worker and the dignity of labour were raised to official status, that artists 'turned to a serious confrontation of the life of the poor and humble: to the depiction of work and its concrete setting as a major subject for art'. Instead of creating allegories based on the ideals of the Revolution, Realist artists turned to popular subject matter 'extolling unvarnished nature and the dignity of the men and women who laboured within it'. Jules Breton, a popular painter of peasant life (fig. 14), stated the case (quoted by Nochlin, *Realism*).

fig. 13 Louis LE NAIN
Peasant Meal
Paris, Musée du Louvre. 1642.
97 × 122 cm.

The treatment of peasant and common subjects in the work of the Le Nain brothers made an obvious link with the interests of nineteenth-century Realism, but Courbet's use of paintings such as this went deeper; he took from them the isolation of individual figures, the apparently haphazard juxtaposition of these figures and their awkward, disjointed pictorial space, all of which were echoed most fully in his *Peasants of Flagey* (Plate 37), although already present in *After Dinner* (Plate 17).

The causes and consequences of that revolution...had a strong influence on our spirits...The was a great upsurge of new efforts. We studied what Gambetta was later to call the new social stratum and the natural setting which surrounded it. We studied the streets and fields more deeply; we associated outselves with the passions and feelings of the humble, and art was to do them the honour formerly reserved for the gods and for the mighty.

Painted in the late autumn and early winter of 1849 in Ornans, the powerful *Stonebreakers* showed two workmen whom Courbet had seen on the road to Maisières and had asked to pose for him. He said to Francis Wey, 'It is rare to encounter the most complete expression of wretchedness, so all at once the picture came to me'. He described the painting in a letter to Wey in late 1849, in succinct and forceful language

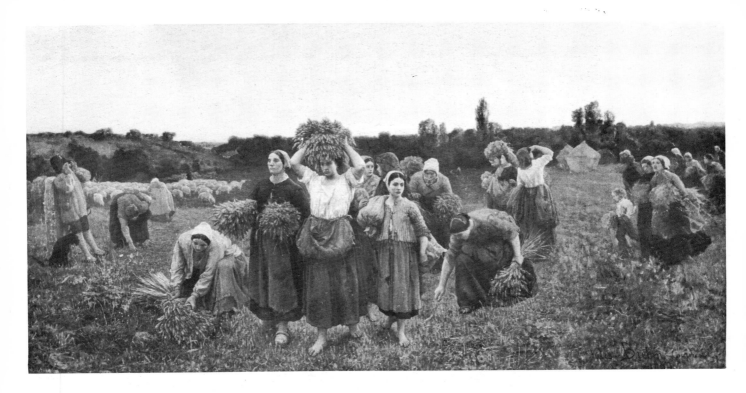

fig. 14 Jules BRETON
The Return of the Gleaners (Artois)
Arras, Musée des Beaux-Arts. 1859.
90·5 × 176 cm.

Breton was one of the earliest painters of
peasant work and the agricultural life of
France, particularly in his native Artois; the
opinion of a contemporary critic of this
painting, who called the gleaners 'beautiful
rustic caryatids', sets the tone of this artist's
treatment of rural labour, endowing the
peasant with a 'pathos and nobility beyond
sheer descriptive actuality' (Nochlin, *Realism*,
1971). A comparison with the stark brutality
of Courbet's *Stonebreakers* (Plate 21) emphasizes
the degree of idealization present in Breton's
apparently straightforward 'social realism'.

which contradicts the myth of Courbet as an illiterate
rustic.

There is an old man of seventy, bent over his work, pick in air, skin
burnt by the sun, his head in the shade of a straw hat; his trousers of
rough cloth are patched all over; he wears, inside cracked wooden
clogs, stockings which were once blue, with the heels showing
through. Here's a young man with his head covered in dust, his skin
greyish-brown; his disgusting shirt, all in rags, exposes his arms and
his flanks; leather braces hold up what is left of a pair of trousers,
and his muddy leather shoes are gaping sadly in many places. The
old man is on his knees, the young man is behind him, standing up,
carrying a basket of stones with great energy. Alas, in this
occupation you begin like one and end like the other! Their tools are
scattered here and there: a back-basket, a hand-barrow, a ditching
tool, a cooking-pot, etc. All this is set in the bright sun, in the open
country, by a ditch at the side of the road; the landscape fills the
whole canvas.

Although not an unknown subject in painting, Cour-
bet's treatment of it was uncompromising. Unlike other
versions of it at this period, for example that of Henry
Wallis (1857, Birmingham, Birmingham City Museum
and Art Gallery) or Millet's *Roadbuilders of Montmartre*

(fig. 15), Courbet confronted the issue directly, without
sentiment or pathos to diminish its impact. He
'concentrates on the task in hand: the action of labour,
not the feelings of the individuals who perform it. And
that is a rare achievement' (Clark, *Image of the People*). It
was hardly surprising that Courbet was criticized for
making his workers no more important than his stones.

The anonymity and inevitable continuity of back-
breaking labour were expressed by Courbet through
the physical substance of his picture; the wooden, static
quality of the kneeling figure in particular, emphasized
by the dark outline separating his torso from the
background, defied all traditional conventions in the
representation of the human figure. 'Unlike Millet's
[figures in the *Gleaners* of 1857 (Paris, Musée du
Louvre)], they lack the time-honoured poses, the
generalized contours, the suave transitions from part to
part of traditional figure styles' (Nochlin, *Realism*,
1971). The figures were static, caught in action in a
landscape that worked rather like a theatrical backdrop
against which they were posed. Apart from a small
triangle of sky high to the right it offered no relief to the
eye in the way of a pleasant, fading rural vista, such as
in Millet's *Gleaners* Instead a sombre wall of hillside
blocked the spectator's eye and relentlessly forced his
gaze to the figures and their work; perhaps it also
represented the cramped oppression of their lives.

If *The Stonebreakers* captured the essence of labour
among the rural proletariat, Courbet's *Funeral at Ornans*
(Plate II) records a social ritual among the bourgeoisie
of rural France. In his advertisement for Courbet's
exhibition in Dijon in 1850, in which the *Funeral* was
shown, the socialist Max Buchon interpreted the
painting as a 'bourgeois dance of Death', seeing Death,

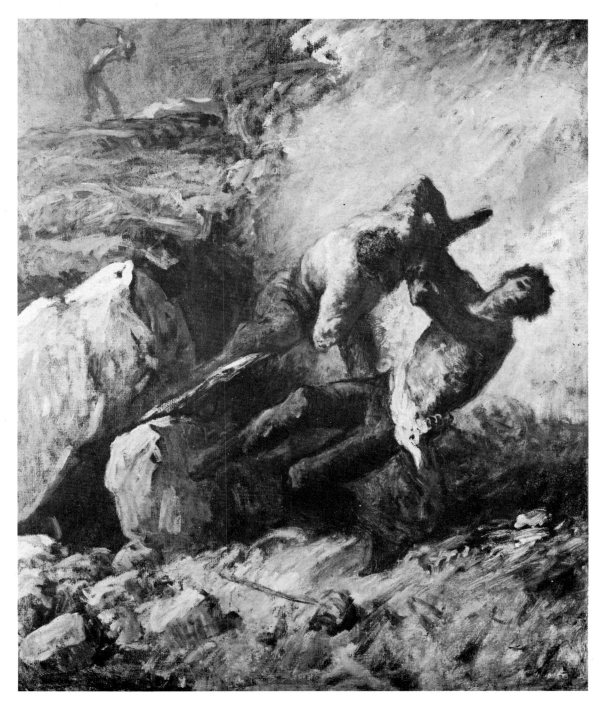

fig. 15 Jean-François MILLET
The Roadbuilders of Montmartre
Toledo (Ohio), Toledo Museum of Art (gift of
Arthur J. Secor). 1846–47. Unfinished oil on
canvas 74 × 60 cm.

Millet's energetic 'heroic' treatment of the
theme of labour, here taking a different aspect
of the same subject found in Courbet's
Stonebreakers, created the antithesis of the static
anti-heroism found in Courbet's work; the
activity and drama in this early work subject
by Millet were completely absent in the
Courbet painting.

represented by the proletarian gravedigger, as an
avenger of 'the poor of the world', whom he saw in *The
Stonebreakers*, which was the second work exhibited at
Dijon. Although Buchon evidently picked out in the
Funeral highly relevant undercurrents which reflected
contemporary class antagonisms in the Franche-
Comté, they were unlikely to have been uppermost in
the artist's conception of his painting. As in his other
Realist works of this period, Courbet set out to
'translate the customs, the ideas, the appearance of my
epoch, according to my own estimation', and the
resultant images were inevitably socially relevant and
challenging, not only because of his choice of subjects
(other artists were creating rural images which were
publicly acceptable through their pathos, ennoblement
or sentimentality), but because of their sheer size and
the uncompromising physicality of his treatment of
them. The actual process by which Courbet crystal-

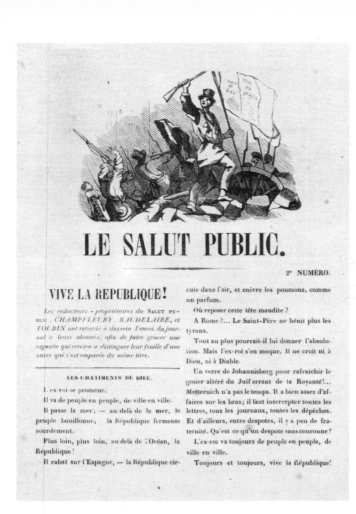

Courbet is not thought to have fought in any
of the confrontations of the 1848 Revolution,
but he did produce this hurried image for
Baudelaire's revolutionary magazine *Le Salut
Public* in March 1848, a parody in almost
popular print style of Delacroix's *Liberty Lead-
ing the People* of 1831 (Paris, Musée du
Louvre). Courbet transformed Delacroix's
allegorical female Liberty into a top-hatted,
be-smocked man of confused class origins, half
bourgeois, half peasant. Concerning the June
Days he wrote to his parents: 'It is the most
distressing spectacle you could possibly
imagine... I am not fighting, for two reasons:
first, because I do not believe in war with rifles
and cannon, it is not consistent with my
principles. For ten years now I have been
waging a war of the intellect alone. I should
not be true to myself, if I acted otherwise. The
second reason is that I have no weapons, and
cannot be tempted. So you have nothing to
fear on my account.'

lized this unalloyed directness is seen in the develop-
ment of the *Funeral* from preparatory drawing to
finished painting.

The preparatory drawing (Plate 22) uses a different,
more elongated format than the painting, the latter
produces a more compact and massed group compared
to the thinner straggle of figures in the drawing. This
denser disposition of figures in the oil eliminated a
portion of the rocky background of the drawing, while
its fatter format allowed Courbet to add more sky,
emphasizing further the solid central band of activity.
The change in the skyline enabled him to strengthen
the crucifix, which he raised up and silhouetted against
the sky. In both drawing and painting there is a
shallow, crowded pictorial space, although in the
drawing the 'atmospheric' lack of definition in the
landscape allows for a greater sensation of space than in
the oil, in which the rocks push forward on to the
figures, none of whom breaks the horizon line. Major
compositional changes in the grouping of the figures
themselves can also be seen; the grave was moved from
the far left to centre (a tentative position appears
sketched in at the bottom centre of the drawing), thus
apparently obviating the pictorial need for the frieze-
like distribution of the proceeding mourners which,
although they were no longer in procession, Courbet
significantly retained. In the drawing the procession
moves from right to left towards the grave, but in the
painting the figures were turned the other way, with
most of the women at the right facing out of the picture,
no longer toward the key section of the scene, the grave.
This changed considerably the atmosphere of the
image, breaking up the drawing's organized continuity
and creating disparate groups of undirected mourners.
A more rhythmic and varied punctuation of the canvas
width was achieved by a greater variation in the row of
figures, which were evenly and flatly distributed in the
drawing, most of them appearing on a level. In the
painting the artist adjusted this overlapping to expose
clearly a larger number of his Ornans sitters; the rows of
men and women to the rear in the drawing have been
lifted up in the oil, as if the ground rose sharply. In
terms of Courbet's aim to record as accurately as
possible the people of his home town, this device was a
perfectly logical means to that end.

In this respect it is of particular relevance to note the
traditional sources commonly cited as having been
used by Courbet for the composition, Rembrandt's so-
called *Night Watch* (fig. 17) and van der Helst's *Captain
Bicker's Company* (fig. 18), both of which Courbet knew
from his visit to Holland in 1846. Apart from the
relevance of the elongated format of the latter, with its
frieze of figures, the elements crucial to both Dutch
paintings were the internal demands which dictated
their form: the fact that both are different resolutions to
the problem of group portraiture. This was a central
concern similarly dictating the careful compositional
structure of Courbet's *Funeral* and responsible for the
change in alignment of the figures between drawing
and painting. Courbet's stiffening and simplifying of
the figures owed much to his interest in popular prints
which, in their function of conveying information,

24

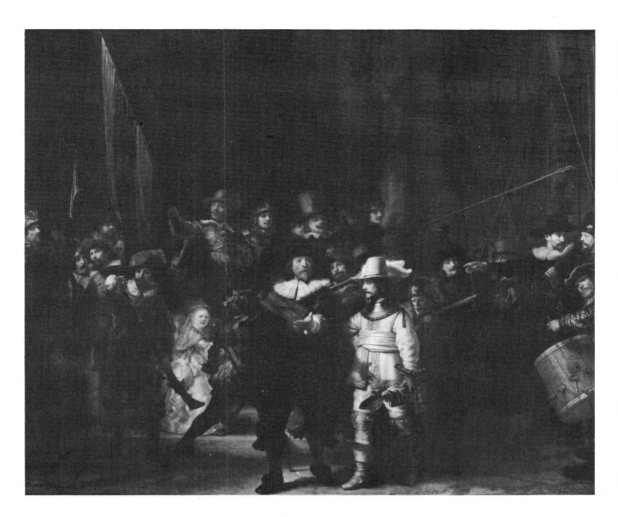

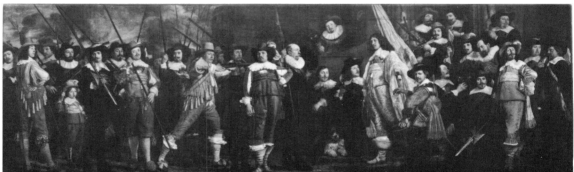

fig. 17 REMBRANDT van Rijn
The Night Watch
Amsterdam, Rijksmuseum. 1642.
359 × 438 cm.

As with the van der Helst painting (fig. 18), Courbet would undoubtedly have seen *The Night Watch* on his visit to Holland in 1846, and while the artist's compositional disposition of his figures in the *Funeral* (Plate II) has nothing of Rembrandt's flamboyant space and gesture, it must nevertheless have showed Courbet the possibilities of treating large groups of people, particularly in terms of the group portrait. Perhaps more importantly, Courbet may have been inspired by this masterpiece in his conception of the nocturnal *Firemen Going to a Fire* (Plate 27), especially as early nineteenth-century critics thought the Rembrandt painting represented a night scene,

because of the darkening effects of time and dirt on the varnish over his strong chiaroscuro handling, thus prompting the painting's nickname, *The Night Watch.*

fig. 18 Bartholomeus van der HELST
Captain Bicker's Company
Amsterdam, Rijksmuseum (on loan from the City of Amsterdam). 1639–43.
235 × 750 cm.

Courbet's visit to Holland and Belgium in 1846 introduced him to a far wider range and quality of northern art than had been available to him in Paris; this van der Helst group portrait was undoubtedly an important source in his conception of the *Funeral at Ornans* (Plate II), a group portrait of many of the local inhabitants of his home town.

adopted a clear, 'cut-out' figure style and simple structure, which Courbet copied; *The Funeral of Marlborough*, an anonymous, late eighteenth-century woodcut, is one of the prints most often cited in this context. Courbet's technical device of uniformity of focus, with no single figure or element dominant and each executed with equal care and concern for verisimilitude, here took on a particular significance, in view of the nature of the subject matter, a group portrait.

There has been discussion and disagreement over the meaning of the *Funeral* ever since its first public appearance in Ornans in spring 1850; some see it within the socio-political context of the period, torn as it was by class struggles and the rise to power of the bourgeoisie through the upheavals of 1848. Most recently Toussaint (*Courbet* 1977–78) stresses the religious implications of the work in relation to the religious attitudes of Courbet's circle, dismissing any political reading. Nochlin states (*Realism*):

He concentrates upon the purely secular import of the burial as an immanent occasion for the social community on earth. Who is being buried is really irrelevant; and so is the fate of the dead man's soul and its relation to the afterlife. Where he is being buried and the nature of the community which participates in this event is what the painting is about – nothing beyond this, but this in all its richness of social and pictorial realism. It is the concreteness, the here and now of the event, that concerns Courbet.

Instead of using the subject as a means to convey a universal truth about life and death, Courbet was interested in this particular funeral, in his own home town, with these particular people, all known to him, participating in the ritual.

Courbet's third painting in the 1849–50 series was the *Peasants of Flagey Returning from the Fair* (Plate 37); here the subject matter depicted was a group of local peasants returning home to Flagey from the fair at Ornans. It was a more conventional subject than the previous two, but Courbet's treatment of it immediately set it apart from any other contemporary scenes of peasant life. The static, awkward poses of peasants and animals were caricatured by critics as wooden dolls, a common reaction to Courbet's figures which self-consciously avoided the picturesque. The pictorial space too is uncomfortable, negating traditional perspectival conventions to produce a startling, unhomogeneous composition; in this, the second version of the subject (the original has disappeared) painted before 1855, certain compositional changes were made, including moving to the centre of the composition a disproportionately large peasant woman with a basket on her head. Her original position can be distinguished in *pentimenti* to the far right, where the basket is still visible against the sky. The man with the pig was also a late addition. Courbet's next major series of pictures of rural life in Ornans concentrated on the rôles of women of different classes performing various typical functions, *Toilet of the Dead Woman* (Plate 25), *Young Ladies of the Village Giving Alms to a Cowgirl in a Valley at Ornans* (Plates III and 28), *The Sleeping Spinner* (Plate 30), *The Bathers* (Plate IV) the *The Winnowers* (Plate VII). *Toilet of the Dead Woman*, traditionally thought to be a toilet of the bride, shows a group of women, well-dressed and evidently from the bourgeoisie, working together washing and dressing a female corpse in preparation for a wake; this was a function traditionally performed by women. The painting seems to be an extension of the theme of death seen in the *Funeral*, a subject which was an obsession in the nineteenth century. *Young Ladies of the Village*, of which a sketch and a final version exist, shows the artist's three sisters as fairly fashionable young ladies, taking a walk and offering typically bourgeois charity to a girl of the peasant class. Thus yet again Courbet produced an image which presented class divisions in rural France, here the more potent for the fact that he shows members of his family, themselves not far away from their peasant origins, as charitable bourgeois. Two of the sisters were the models for the later *Winnowers*, or *Farmers' Daughters from the Doubs*, where they appeared as working women, but from a farming rather than peasant family, not quite bourgeois, not quite peasant, reflecting the status of the Courbet family itself. Thus these images in which his siblings appear contain ambiguities which were an inherent part of his family's social position.

In *The Winnowers* there was again a disjointed treatment of space and of the figures within it; the two women appear ambiguously close, as also does the boy. His relationship to the central woman's raised arms brings him dramatically forward in the pictorial space. The whole composition is in a shallow pictorial space, pushed up close to the picture plane; this was emphasized by the lack of tonal recession in the walls and the bright sheet on the floor and by such elements as the door in the top right, which was placed parallel to the picture plane. The major device used to create depth is the receding half-open chest, which is also darker than the rest of the painting, but whose effect is counteracted by the ambiguous space between the boy and the central female figure. The similarity in scale between the straw basket in the foreground right and the dish apparently behind the boy increases the sense of shallow space. The effect of the space and of the rich bright palette used by Courbet was to create a powerful and direct image, unavoidable in its impact. Its strength was moderated by the echoing curves of the arms and sieve and the bowls, individual still-lifes which evoke the domestic scenes and still-lifes of Chardin.

Courbet's *The Meeting* (Plate V), which has been called his definitive self-portrait, shows the artist meeting his new patron, Alfred Bruyas, and his servant on a road outside Montpellier at the beginning of his first visit to the collector, in May 1854. The artist's self-confidence, which he often represented as more secure

than it actually was, here seems unassailable; his pride in his craft, as in *The Artist's Studio* (Plate VIII), is an underlying message in a work depicting himself as the travelling landscape painter, carrying with him all his equipment. Obviously a minimum of bulk and weight was essential, and special equipment was being developed by colour merchants and manufacturers to meet the increasing demand of artists and amateurs for suitable materials. The slim haversack, of which the side pocket is visible at Courbet's elbow, probably contained the artist's personal effects; a flat painting box was strapped lengthways to this and would have contained not only his oil colours but also brushes, rectangular wooden palette, oil and turpentine and one or two small canvases or oil sketching boards for work from nature. At the top of the pack, beneath his slung coat or cape, can be seen the white points of his collapsible parasol, used to protect the artist's eyes from reflected sunlight which, dancing off the wet canvas surface, could prevent his seeing the painting. In addition to all this, the folded, collapsible sketching easel is visible, a three-legged object whose sharp feet could be pushed into the ground for the necessary solidity. The composition of this painting was based on a popular print from Le Mans, from the workshop of Pierre Leloup (fig. 5).

In progress by the autumn of 1854, *The Artist's Studio* was Courbet's first major work on a monumental scale since the unsuccessful *Firemen Going to a Fire* (Plate 27); as with the *Funeral*, it was painted in Courbet's small studio in Ornans, in the attic of the house in the Place des Iles Basses, which had been left to Courbet by his maternal grandfather Jean-Antoine Oudot. All three paintings were so large that there were only inches to spare relative to the size of the studio, while other problems arose because, due to the lack of space, Courbet was unable to stand far enough back to study the work in progress. When Courbet wrote to Champfleury about *The Artist's Studio* in the autumn of 1854, he remarked that he had only enough time left to spend two days on each figure, not leaving time spare for the treatment of accessories, before the canvas had to be ready for submission to the jury of the Universal Exhibition that was scheduled to open the following year; in the end Courbet had to seek a postponement when his work was still unfinished.

Courbet's letter to Champfleury describes the painting during its progress, and although changes were made by the artist after the letter, it contains valuable information on the origins and content of the picture.

It is the moral and physical history of my studio . . . all the people who serve my cause, sustain me in my ideal and support my activity; people who live on life, those who live on death; society at its best, its worst and its average – in short, it's my way of seeing society with all its interests and passions; it's the whole world coming to me to be painted.

Courbet indicated that the figures on the left of the canvas were those who lived off death, while those on the right, his friends, critics and fellow-thinkers, were the people who lived on life. In the centre was Courbet himself, orchestrating the whole scene, working on a landscape of his home region, the Franche-Comté, with his muse-like model looking over his shoulder as he worked. A young boy looks on, while another, perhaps the artist's unacknowledged son Désiré Binet draws on the floor to the right. A large white cat plays awkwardly in the foreground.

Interpretations of the meaning of this painting, which was evidently intended to be iconographically complex even at the time, for Courbet wrote 'it's passably mysterious. Let him who can guess' (Léger, 1929), have been astoundingly numerous and varied. They range from the purely aesthetic view of it as a statement of the independence of the modern artist, in which the artist and the act of painting itself become the subject of the painting, to the overtly socio-political, passing through every possible combination in between. In a recent, new and fascinating interpretation, Toussaint (*Courbet* 1977–78) suggests that each of the figures on the left of the great canvas, those who live on death, can be seen as representing an important political figure, group or event from contemporary European revolutionary history, from both the political left and right. The analysis seems to draw no conclusions from this new material, but if this inventory is accurate, it puts a highly significant new slant upon the intentions of the painting, implying a much greater political awareness and sophistication on the part of Courbet than has hitherto been suspected. It would seem to indicate a much more direct political iconography in Courbet's art than has previously been observed, and at the same time this evidence would tend to contradict a popular view of Courbet as an apolitical artist unconcerned with contemporary social upheavals. The fact that Courbet associated these political figures with 'living on death' may suggest that he had become disillusioned with violence as a means to radical social change and that his emphasis on his 'fellow-thinkers' as those who lived on life intimates a commitment to revolution by means of the pen and not the sword. Toussaint's most important contribution in the interpretation of this painting is, perhaps, her analysis of Masonic imagery, suggesting that Courbet may himself have been a Mason.

A laboratory analysis of this painting (*Courbet* 1977–78) highlights the question of Courbet's techniques and of his grounds in particular. The paint handling varied from the application of the dark hues with broad, supple brushstrokes to the use of a knife to work large, flat areas of light colours. Courbet is known to have used a *couteau anglais*, a brand of flat, flexible knife in a variety of shapes designed for painting, which by the turn of the twentieth century was widely available. The palette knife, traditionally made of

ivory or iron and of steel by the 1850s, was used for mixing oil colours to the required consistency before transferring them to the palette. The *couteau anglais* was used for painting and was sometimes called the 'painting knife'. Longer and broader than the palette type and made of steel, it seems to have been a nineteenth-century development; Courbet must have been not only its most enthusiastic and talented exponent of the period, but must also have played an important rôle in increasing its popularity. It is likely that he had his especially made, probably in England as its name suggests, where the best steel must have come from at that time. Max Buchon, in his *Salon of 1868*, wrote at length on Courbet's use of the knife in painting.

I do not know whether great artists of the past have employed it as a supplement to the brush and have used it to paint with; what I do know is that in this century Courbet makes constant use of it, and that he achieves extraordinary effects with it. The amplitude of execution and the beauty of colouring that all the world recognizes in him come in part from this. Put in place with the knife, the tone acquires a delicacy, a transparency that the brush is incapable of giving it...Courbet, moreover, handles this instrument with unequalled dexterity. He has, I think, improved it; he has lengthened it, given it two parallel edges, has made it so flexible and supple that one would think it a pen in his fingers. There are landscapes by him...where ground, sky, water, tree trunks, and leaves - everything - is made with the knife. It is only for the animals and the human figure that he takes up the brush, because then the brush gives him at the same time as the movement of the muscles, the tone be it of fur or of flesh. I remember the time when Courbet had an atelier [January to April 1862]. His students, amazed by the nimbleness of his hand, all had knives made like the one they saw him manipulate with such ease. But alas! The art of the colourist is not completely within the instrument; it is also, it is above all, in the trustworthy mirror of the eye that distinguishes at first sight the tone and the values of tone. Few succeed in their first attempt.

It is significant here to refer to Courbet's grounds, which usually provided the tonal basis for the sombre palette of his major works. He was renowned for his use of a traditional red-brown ground, although it appears that on occasion he used even darker ones. The chemical paint analysis (see p. 65) of *The Wounded Man* (Plate 33) revealed that the original painting on this canvas had been worked on a white ground, with no dark lay-in or wash to mute it. *The Artist's Studio* (Plate VIII) is discussed in a laboratory report which points out that its warm tonality was produced by a thin paint layer worked over a warm ground of varying tawny and brown-red colours, principally iron earths, mixed with only small quantities of oil binder considering the absorbency of the colours used. This resulted in an unusually matt surface (*Courbet* 1977–78). The varying colours of the ground were probably the result of inadequate mixing and the fact that the ground was put on without especial care; the vast area of the canvas to be prepared may have been the cause of the irregular ground, but its irregularity may also indicate that it was roughly prepared by the artist himself rather than by a colour merchant. The patch-work of canvas strips used for the picture and sewn together at the same time, with no later additions (see *Courbet* 1977–78), may also have been an amateur job; a letter to Bruyas from Zoé Courbet, the artist's sister, on 6 December 1854 notes 'I have just prepared canvases for Gustave.' This may not refer to that for *The Artist's Studio*, but it implies that she was involved in some aspect of canvas preparation for her brother, perhaps even laying grounds. Apart from his very large scale works, the majority of Courbet's paintings were on standardized commercial canvas formats, made specifically for 'figure', 'landscape' or 'seascape'.

A steady constant throughout Courbet's *oeuvre*, but which became a more active interest in the 1860s, was his treatment of the female nude. One of his earliest oils on the theme was *Sleeping Blonde* (Paris, private collection) of c. 1849. Even in this comparatively early work the artist's love of female flesh, in particular solid hips, buttocks and belly, is already in evidence; his delight in female hair, a common fetish in the nineteenth century, for instance among the Pre-Raphaelites, is also present in his treatment of the flowing curls lying across the skin of her neck. The strangely foreshortened pose used was one which cropped up only occasionally in his studies of women, most of his later nudes in particular adopting the full-length supine position, lying parallel to the picture plane. As in the *Sleeping Blonde*, Courbet often chose to depict women in the vulnerable state of sleep, exposed and submissive to the eyes of the, by implication, male spectator. As in many traditional representations of the female nude, Courbet, even when his women were not shown asleep, painted them so that there was no confrontation between nude and spectator, no significant eye contact, such as Manet used in his *Olympia* of 1863 (Paris, Musée du Louvre) in which the model defiantly confronts the viewer, who is faced with a strong, independent and definitely non-submissive personality. Although Courbet's nudes were not idealized in the way of fashionable nudes of his day, they nevertheless conformed to very traditional patterns of representing woman as a passive sexual object.

It is significant in this respect to have the opinion of at least one member of Courbet's circle on the rôle of women; Pierre-Joseph Proudhon was portrayed by Courbet in 1865, the year of his death, showing the writer as he had been in 1853 (Plate 56). The original state of this composition included Proudhon's wife seated insignificantly in the background; after the Salon of 1865 Courbet obliterated her figure completely, putting in the present chair and wifely mending. In the summer of 1853, when the painting was set, Mme. Proudhon was heavily pregnant with their third daughter Stéphanie, a choice of moment not without significance as for Proudhon, and many other socialists at this period, woman's highest calling in life was motherhood; her place was in bed or in the kitchen,

and her chief task was raising the man's children. Proudhon wrote:

... rather seclusion than emancipation. Woman must always be a minor or an apprentice. To give her political rights was profligacy or pornocracy. Only man must have the right to divorce; any woman who complains must be guilty and sent back to her household.

According to Proudhon, a woman could only be either a housewife or a courtesan, a life-style adopted by many woman at the period as the only available means to independence. Courbet echoed his friend's sentiments in the hierarchy of his picture: Proudhon, next his two daughters and finally in the background, his wife. That women, apart, of course, from his sisters, were intended for delectation and little else is clear from Courbet's nude studies.

The artist's own attitudes to a wife, a family and marriage were expressed at the time of the departure of his long-standing mistress Virginie Binet and their son Désiré in the early 1850s; she married in 1854 for the security which Courbet refused to provide. 'I shall miss my boy very much, but art gives me enough to do without burdening myself with a household; moreover, to my mind a married man is a reactionary', Courbet wrote in a letter to Champfleury during the winter of 1851–52. Elsewhere he stated: 'The extreme love that one can have for a woman is a sickness; it absorbs the thinking faculties....' The notion of art as being incompatible with married life, of the debilitating effects of love and of the artist needing to devote all his energies to creativity had its origins in Romanticism, in the life-style and ideas of men like Théodore Rousseau, who saw painting as his only mistress, equating art with woman and the creative act with the sexual act. For Rousseau, celibacy was essential to preserve his creative powers, and he associated artistic potency with sexual abstention and a life free from commitment to women. Balzac extended the equation to its logical conclusion, with the common analogy between the creative act and the birth of a child; the artist, having first inseminated the seed of his idea, toils to bring to fruition his 'baby', the finished work of art:

To pass from conception to execution, to produce, to bring the idea to birth, to raise the child laboriously from infancy, to put it nightly to sleep surfeited, to kiss it in the mornings with the hungry heart of a mother, to clean it, to clothe it fifty times over in new garments which it tears and casts away, and yet not revolt against the trials of this agitated life – this unwearying maternal love, this habit of creation – this is execution and its toils.

Apart from Courbet's boasting 'comic promiscuity depicted in a letter to Buchon and in another to Alfred Bruyas'. (Clark, *Image of the People*), little is known of the artist's sexual life; Lindsay suggests that Courbet was in fact frightened of sexual matters, and Castagnary recorded that 'Woman in his life never went beyond the second order. She was a companion; she was a model.' This statement recalls the submissive rôle of sexual object which predominates in Courbet's depiction of nude women; he wrote, 'Woman, who lacks the aesthetic and dialectic facilities, should be submitted and faithful to man' and 'Work necessitates the domination of the senses and the conservation of one's authority over women.' The importance to Courbet of the submissive image of women was made concrete in his painting (Plates 30, IX, 62, XI, 63 and 69). One of Courbet's most assertive nude women appeared in his *Bathers* in which one model, adopting a classical pose for her large body, defiantly turns her back on the spectator. The mutual appreciation between women hinted at in this composition was taken up by Courbet more fully in later works such as *The Awakening* (Plate 62) and *Women Asleep* (Plate XI), in which the popular nineteenth-century theme of lesbian love found expression. After his youthful amorous self-portraits, these are the only major images of love in the artist's *oeuvre*. They provide a titillating but significantly non-threatening, non-competitive area of sexuality in which he evidently felt free to delight.

Courbet's Realism after the 1850s is considered by most experts to have been weaker and less uncompromising than that of the earlier period. As early as 1861 Champfleury regretted the reassuring qualities of the artist's *Dead Roe-Buck* of 1858 (The Hague, Rijksmuseum Mesdag), which he said had 'attracted the timid souls who, seeing only a *dead animal* in a landscape, and being no longer frightened by a representation of man, sought to push the artist along a second-rate track.' However, by this date the relations between writer and artist were increasingly unfriendly, leading to their final rupture in 1865, and his opinion on Courbet at this date may have been coloured by their disagreements. But from the mid-1860s Courbet was increasingly accepted and in public demand, particularly for his landscapes and portraits; he wrote to his family from Trouville in November 1865, exaggerating his good fortune in flamboyant style.

My fame has doubled and I've grown acquainted with everyone who might be of use to me. I've received more than two thousand ladies in my studio, all of whom want me to do their portraits after seeing those of Princess Károly and Mlle. Aubé. Besides the portraits of women, I've done two of men [Plate 57] and many sea-landscapes [Plate 59]. In a word I've done 35 canvases: which has astounded everyone.

At the Salon the following year Courbet's work had a resounding success. Frédéric Bazille wrote to his parents in April 1866:

This is what fashion can do! In all his life he has not sold more than 40,000 francs worth of paintings. It's true this year he exhibits some very beautiful things, yet they are certainly inferior to his *Bathers* [Plate IV], his *Demoiselles de la Seine* [Plate IX], etc. The public, however, has made up its mind to prepare success for him, and since the opening of the Salon he has sold more than 150,000 francs worth of pictures. His drawers are bulging with bank notes; he doesn't know any more what to do with them. All the collectors besiege him, rummage through a lot of dust-covered old stuff and frantically compete for it.

Emile Zola, writing in *L'Evénement*, attributed Courbet's success to his decline as an artist; accusing him of loss of vigour he stated that 'the admiration of the crowd is always in direct ratio to individual genius. You are the more admired and understood as you are the more ordinary.'

The following year Courbet continued to gain public approval, while his one-man show, arranged to coincide with the World Fair of 1867, was considered a disappointment by his fellow artists. Monet thought his recent canvases terrible, and one of Cézanne's friends, although deeply astonished by Courbet's 'immense and integral power', found the latest paintings 'awful: so bad they make you laugh'. By this time Courbet's health was declining; he had always drunk heavily, it was part of his mask of bravado and no doubt a solace, but he became an alcoholic. During the Paris Commune Courbet had a brief return to the revolutionary cause of his youth; he became President of the Art Commission and was later alleged to have been responsible for the destruction of the Vendôme column, the symbol of Napoleonic Imperialism. He was imprisoned for six months at Sainte-Pélagie during the last months of 1871 and the first few of 1872; in July 1873 Courbet crossed the border into Switzerland, where he spent the four last years of his life in exile. His words written to his patron Bruyas in November 1854 were never more apt than at this time. 'Behind this laughing mask of mine which you know, I conceal grief and bitterness, and a sadness which clings to my heart like a vampire. In the soociety in which we live, it doesn't take much to reach the void.'

Selected Bibliography

Berger, K., 'Courbet in his Century', *Gazette des Beaux-Arts*, 1943.

Borel, P., *Lettres de Gustave Courbet à Alfred Bruyas*. Geneva, 1951.

Bowness, A., *Courbet's 'l'Atelier du Peintre'* (Fiftieth Charlton Lecture, 1967). Newcastle, 1972.

Bowness, A., 'Courbet's Early Subject-Matter', *French 19th Century Painting and Literature* (U. Finke, ed.). Manchester, 1972.

Clark, T.J., 'A Bourgeois Dance of Death: Max Buchon on Courbet', *The Burlington Magazine*, 1969.

Clark, T.J., *Image of the People: Gustave Courbet and the 1848 Revolution*. London, 1973.

Clark, T.J., *The Absolute. Bourgeois: Artists and Politics in France 1848–1851*. London, 1973.

Courthion, P., *Courbet*. Paris, 1931.

Courthion, P., *Courbet raconté par lui-même et par ses amis*. Geneva, 1948–50.

Daulte, F., *Frédéric Bazille et son temps*. Geneva, 1952.

Davies, M., *National Gallery: Catalogue of the French School*. London, 1970.

Delbourgo, S., and Faillant, L., 'I. Courbet du copyiste au maître' in 'Contribution à l'étude de Gustave Courbet' in participation with Madeleine Hours and Marie-Thérèse de Forges in *Laboratoire de recherche des Musées de France, Annales*, 1973.

Ellman, M., *Thinking About Women*. New York, 1968.

Fernier, R., *Gustave Courbet*. London, 1970.

de Forges, M.-T., *Autoportraits de Courbet (Les dossiers du département de peintures*, no. 6), Catalogue of exhibition at Musée du Louvre, Paris, 1973.

Gustave Courbet 1819–1877, catalogue of exhibition at the Philadelphia Museum of Art, Philadelphia and the Museum of Fine Arts, Boston, 1959–60.

Gustave Courbet (1819–1877), catalogue of exhibition at the Académie de France, Villa Medici, Rome, 1969–70.

Gustave Courbet (1819–1877), catalogue of centennial exhibition at the Grand Palais, Paris and the Royal Academy, London, 1977–78.

Herbert, R.L., 'City Vs. Country: The Rural Image in French Painting from Millet to Gauguin', *Artforum*, 1970.

Jean-Aubry, G., *Eugène Boudin*. London and Greenwich, Connecticut, 1969.

Léger, C., *Courbet*. Paris, 1929.

Léger, C., *Courbet et son temps*. Paris, 1948.

Lindsay, J., *Gustave Courbet, His Life and Art*. London, 1973.

Mack, G., *Gustave Courbet*. London, 1951.

Mac Orlan, P., *Courbet*. Paris, 1961.

Meltzoff, S., 'The Revival of the Le Nains', *Art Bulletin*, 1942.

Jean-François Millet, catalogue of exhibition at the Petit Palais, Paris and the Hayward Gallery, London, 1975–76.

Nicolson, B., *Courbet: The Studio of the Painter*. London, 1973.

Nochlin, L., *Gustave Courbet: A Study of Style and Society* (originally submitted as a doctoral thesis, New York University, 1963). New York and London, 1976.

Nochlin, L., 'Gustave Courbet's *Meeting*: A Portrait of the Artist as a Wandering Jew', *Art Bulletin*, 1967.

Nochlin, L., 'The Invention of the Avant-Garde in France 1830–1880', *Avant-Garde Art* (T. B. Hess and J. Ashbery eds.). London, 1968.

Nochlin, L., *Realism and Tradition in Art 1848–1900*. Englewood Cliffs, 1966.

Nochlin, L., *Realism*. London, 1971.

Rewald, J., *The History of Impressionism* (3rd edition). London, 1973.

Riat, G., *Gustave Courbet, peintre*. Paris, 1906.

Richardson, J., *The Courtesans*. London, 1967.

Rosenthal, L., *Du romantisme au réalisme*. Paris, 1914.

Schapiro, M., 'Courbet and Popular Imagery. An Essay on Realism and Naïveté', *Journal of the Warburg and Courtauld Institutes*, 1941.

Scharf, A., *Art and Photography*. London, 1968.

Sloane, J.C., *French Painting between the Past and the Present: Artists, Critics and Traditions from 1848–70*. Princeton, 1951.

Sterling, C., and Salinger, M.M., *French Paintings. A Catalogue of the Collection of the Metropolitan Museum of Art*. New York, 1967.

The Plates

1 *Portrait of Régis Courbet, the Artist's Father*
BOULOGNE-SUR-SEINE, private collection. c. 1840? Stamp of the studio sale, lower left (1919).
73 × 59·5 cm.

This portrait of the artist's father (1798–1882) has been variously dated to between 1842 and 1844; the *Courbet* 1977–78 catalogue gives a revised and earlier date to this youthful work. For this portrait steeped in the classical tradition, Courbet used a style typical of his early studies of friends and family, more formal than the intimate, Romantic mode we see in his self-portraits of the 1840s. Courbet here chose an almost full profile view of his sitter, with a three-quarter bust; this was probably the most straightforward and undemanding pose he could have selected, reinforcing the early date for its execution. The fall of soft light, visible on the blank wall behind the sitter, is cast almost too evenly on Régis Courbet's face, the modelling of which would in fact indicate a light source from the right of the picture. The clarity of brushwork in the handling of the flesh passages draws the eye to them, reinforced by the contrastingly dark, sombre tones elswhere in the painting. The artist showed 'some hesitancy and awkwardness in separating the figure from the classically bland background; reworkings in the bottom left-hand corner indicate difficulties in rendering the turn in space of the sitter's forearm, and the whole length of this contour relates ambiguously to the background, leaving spatial recession inadequately defined.

2 The Mouth of the Seine
LILLE, Musée des Beaux-Arts. 1841? Signed lower left: G Courbet. 43 × 65 cm.

Toussaint (*Courbet* 1977–78) suggests this new early dating for this seascape, traditionally dated to 1859, when Courbet met Boudin in Honfleur. Its timidity is the reason for considering it much earlier in date, and it was in 1841 that Courbet first visited the Normandy coast with his friend Urbain Cuénot; it is likely that it was retouched by Courbet at a later date. The two diminutive, picturesque figures in the foreground are of a man and a young lady sketching from nature, by then a popular pastime among the leisured classes.

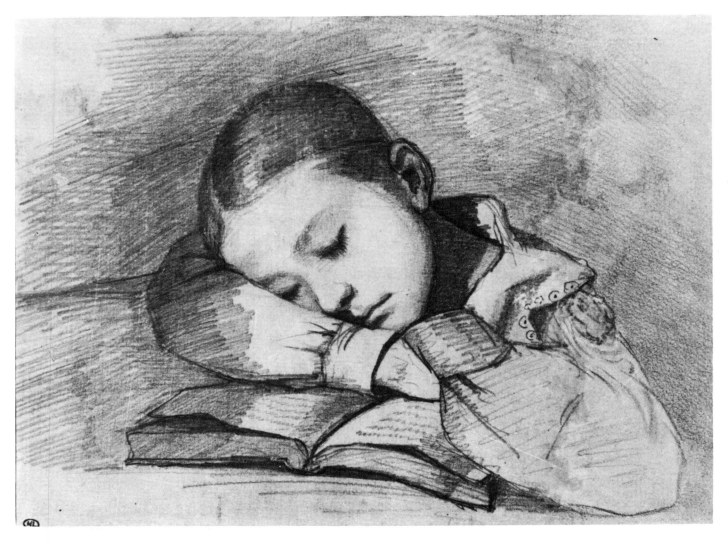

3 *Portrait of Juliette Courbet*
PARIS, Musée du Louvre, Cabinet des Dessins. c. 1841? Unsigned. Graphite on paper 20 × 26 cm.

This delicate but rather tentative drawing has been dated to c. 1841 on the basis of the similarity in age of the sitter, who was then ten years old, in an oil portrait of that year.

4 *Little Portrait of the Artist with a Black Dog*
PONTARLIER, Hôtel de Ville. 1842. Initialled lower left: G.C. 27 × 23 cm.

Although this painting is now firmly dated (*Courbet* 1977–78) on the basis of a letter to his parents in May 1842 concerning the acquisition of the black dog seen in this painting, the artist appears immature for his then twenty-three years. The soft, unmarked features and the fine, small-boned hand surely belong more readily to a youth in his teens; however, Courbet may well have idealized and romanticized his image here. The pose harks back to portraits of the seventeenth century, with the sitter leaning on a table or window-sill, the latter in particular identifying the window with the picture plane and thus giving the impression that the sitter leans out beyond the canvas into the spectator's space, as for example in Gerrit van Honthorst's *Merry Violinist* of 1623 (Amsterdam, Rijksmuseum). Courbet, however, used this device rather differently, with the table tipping up at a strangely high angle (a line to the right of it shows it has been extended) and seeming to act as a barrier between artist and spectator. Again struggling with the problem of 'releasing' the figure from the plain background, the artist adjusted the lighting around the head and body, particularly above the left shoulder where a dense highlight accentuates the dark contour. The flowing locks and shaded, intense eyes are a reminder of Courbet's Romantic allegiances during this period. In most of the picture the paint is thinly applied, exposing the coarse but even texture of the canvas grain; especially along its bottom and top edges the wavy movement of the grain of the canvas indicates the strain against the tacks holding the canvas to the stretcher. It would appear that some adjustment was made by the artist to the angle of the upper arm leaning onto the table. This may account for the exceptional shortness of the forearm from elbow to wrist, although it is evident that Courbet has not taken foreshortening into account in this self-portrait.

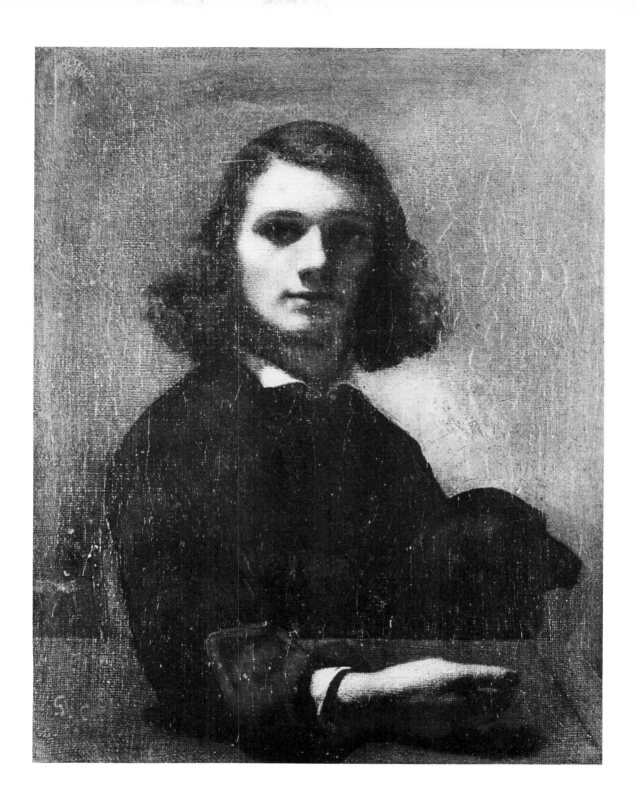

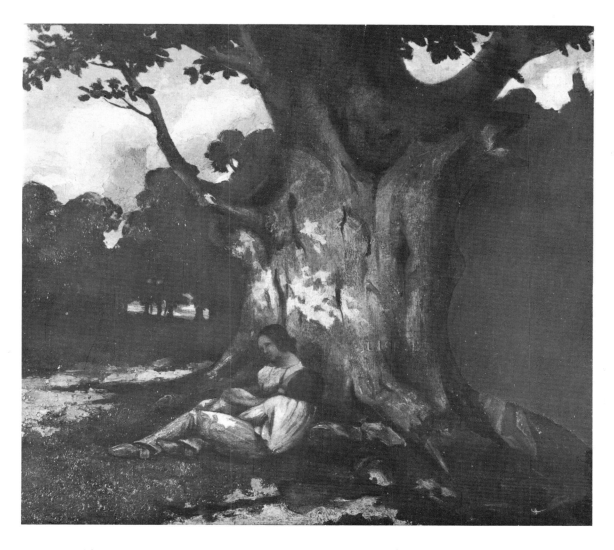

5 *Portrait of Paul Ansout*
DIEPPE, Château Musée. 1842–43? Signed with a point into the wet paint, lower left: Gustave C.
81 × 65 cm.

This painting of a friend of Courbet, along with the portrait of the artist's sister Juliette (Plate 9), is the most Ingresque of his early portraits; the tight drawing and more explicit treatment of form in space make this a much cooler portrait than that of the artist's father (Plate 1). Here a decorative if rather dead background is used to strengthen the difference between it and the sitter, and the form of the figure is enhanced by the check design and stripes on trousers and shirt respectively. The sombre tone of the background pushes the figure forward, but also creates a somewhat oppressive, claustrophobic atmosphere which is to be found in many of Courbet's paintings throughout his *oeuvre*. The treatment of light is crisp to the point of harshness, stressing the angularity of the sitter's features and contrasting sharply with the surrounding rich darks. Here again the direction of the light source is ambiguous, for while the sitter is flooded with light from the right of the picture, a softer light catches only a slab of the background and is not comprehensible in naturalistic terms. The overall treatment shows greater confidence than in the earlier portrait of Courbet's father, and Ansout's face has an almost sculpted clarity and precision. On the table beside the sitter can be seen an open book entitled *Paroles d'un croyant* (*Words of a Believer*, see Toussaint, *Courbet* 1977–78), and the beginnings of a suitably filial letter to 'my dear mother'. Both Ansout and Courbet were away from their families, studying in Paris at this date.

6 *The Large Oak*
PARIS, private collection. 1843? Unsigned. Annotated on trunk of tree: LISE ET. 29 × 32 cm.

Although de Forges (1973) indicates that Courbet's name follows that of Lise on the tree-trunk, it appears that it is simply rumour that has in fact added the artist's name; however, it is highly likely that this is a self-portrait with a lover, Lise, even though the man's features are turned away from the spectator. Courbet was in the habit of celebrating his youthful amorous adventures in his painting, as, for instance, in *The Lovers in the Country* (Plate 12) and other variants (Paris, Musée du Petit Palais and de Forges, 1973, no. 29). In this small painting the huge trunk of the oak dominates the foreground, with the two diminutive and rather awkwardly portrayed figures beneath it. To the left a vista towards the horizon is left open, with trees silhouetted in the distance, while to the right the view is closed by dense trees. This must be one of the artist's earliest wooded scenes.

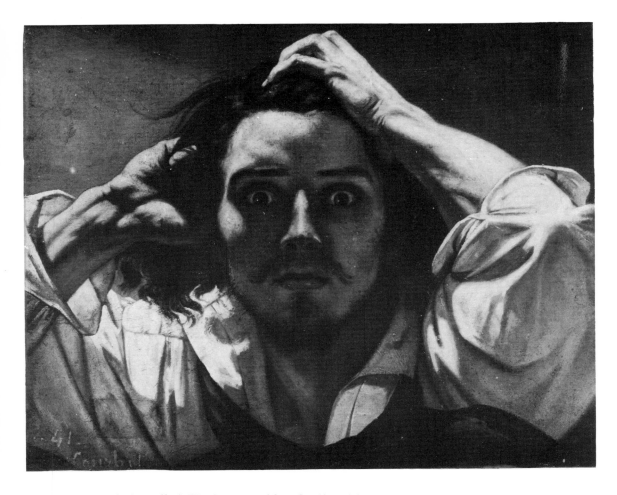

7 *Portrait of the Artist*, called *The Desperate Man* (*Le désespéré*)
LUXUEUIL, private collection. 1843–44? Signed and dated lower left: . . 41 G. Courbet [probably spurious]. 45 × 54 cm.

Many of Courbet's early self-portraits are difficult to date; in some, for instance the dated *Sculptor* (Plate 10), the artist's image is stylized and cannot be used as a basis for identifying his changing features. In others, such as the Luxueuil painting, the date is obviously incorrect and the signature in general open to suspicion. Courbet had a habit of dating his works in the year they were exhibited rather than executed, which is often a source of confusion in establishing a chronology. The artist's features in this painting, the long hair and the new growth of beard, seem very similar to those in *The Lovers in the Country* (Plate 12), the variant of which (Paris, Musée du Petit Palais) is dated, plausibly, 1844, and was probably painted at the same time as the original. De Forges (1973) dates this extraordinary self-portrait to 1845, while Toussaint suggests an earlier date of 1843 (*Courbet* 1977-78); I put it closer in date to *The Lovers in the Country*.

I *Portrait of the Artist*, called *The Man with the Leather Belt*
PARIS, Musée du Louvre. 1845–46? Signed lower left: Gustave Courbet. 100 × 82 cm.

De Forges (1973) identifies this portrait as the one accepted at the Salon of 1846 and shown under the title *Portrait of M. XXX*. When exhibited at the one-man show organized by Courbet in 1855 this painting was subtitled in the catalogue 'Study of the Venetians', and despite the fact that Courbet repeatedly stated that this portrait was in fact inspired by Velázquez, an x-ray has shown that it was painted on top of a copy of Titian's *Man with a Glove* (fig. 8) in the inverse position, thus confirming a stylistic link intuited by several art historians. A study of the painting in raking light reveals the head-shaped under-work of the Titian copy beneath the elbow and fore-arm of the artist in the final version; thus by inverting the copy Courbet was able to exploit elements of it in the self-portrait on top. Similarly the white collar and shirt-front of the copied Titian provided the basis for the artist's elegantly curved right hand and his cuff. The heavy layers of paint involved in the re-use of this canvas have resulted in the cracking of the paint surface, particularly in the area of the figure where the paint is inevitably thickest. The artist's plaster cast, seen also in the *Game of Draughts* (Plate 11) and called 'of Michelangelo', is dimly visible to the artist's right; it would have been clearer when the canvas was first completed, but the colour has darkened and sunk with age. Beneath the artist's elbow lies a thick book, possibly a volume of engravings, upon which also rests a metal chalk-holder, a piece of drawing equipment typically found in artists' studios prior to the invention of the propelling pencil towards the end of the nineteenth century. Although white chalk is installed in the holder here, they were used for almost every type of drawing material.

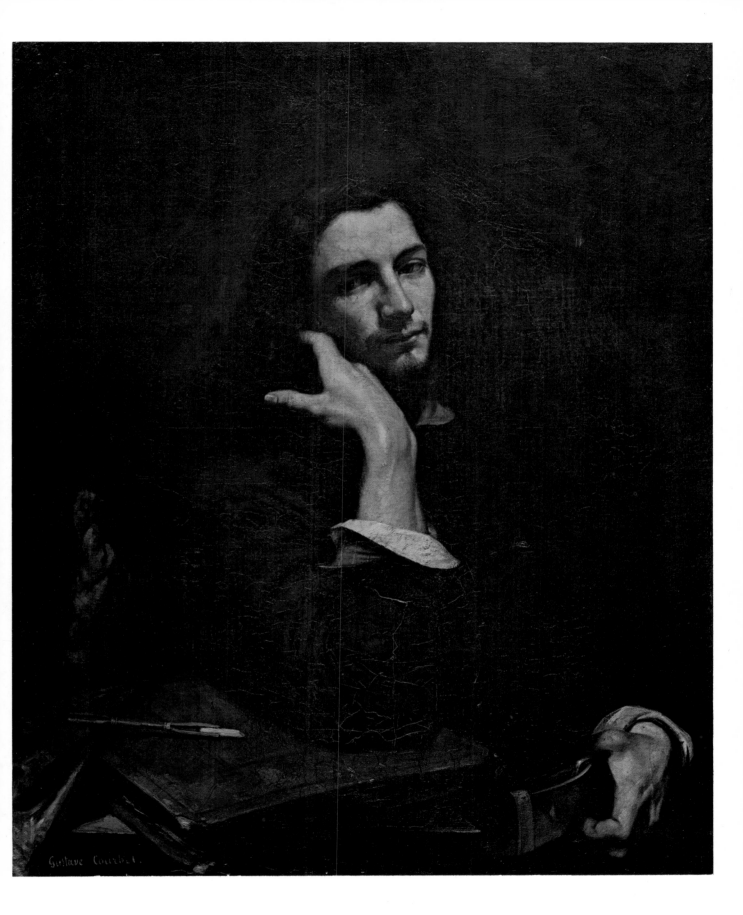

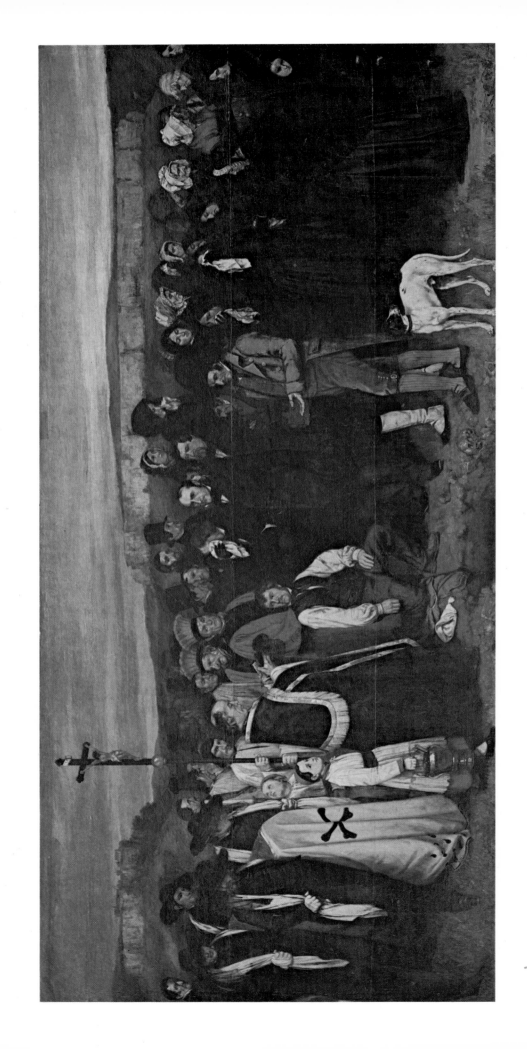

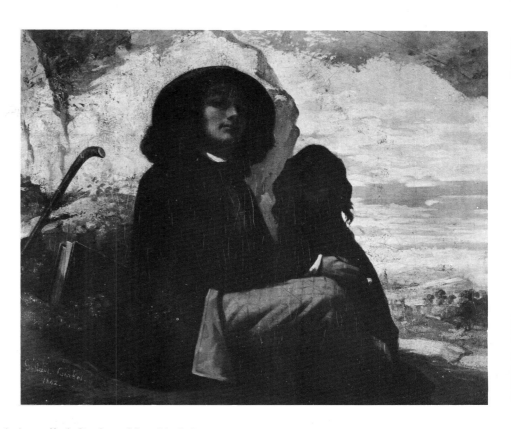

8 *Portrait of the Artist*, called *Courbet with a Black Dog*
PARIS, Musée du Petit Palais. 1844? Signed and dated lower left: Gustave Courbet 1842. 46 × 55 cm.

This portrait has compositional links with the *Little Portrait* (Plate 4), and *Courbet with a Black Dog* may have its origins in the earlier work. It has evidently undergone considerable revision, particularly in the background which has been altered to the present rectangular format from a curved upper edge, the lines of which are still visible. It has been suggested that the painting may have been intended originally by Courbet as a mural, perhaps for over a door, hence the shaped canvas and the low viewing angle suggested by the composition and the artist's gaze. Thus this painting may have been begun around the date of the earlier portrait, 1842, although the artist appears more mature in the present work, and then reworked before its appearance in the Salon of 1844, where it was the first of Courbet's paintings to be accepted. Again Courbet included chequered patterned trousers which help to describe the form of the leg by following its contours; his use of the painting knife to apply his colours is already in evidence here, notably in the top area of the sky and in the rocks behind the figure.

II *Funeral at Ornans*
PARIS, Musée du Louvre. 1849–50. Signed lower left: G. Courbet. 315 × 668 cm.

When considering this painting it is crucial to remember the impact of its vast scale; all the figures are life-size and it is over twenty feet wide. It is therefore an event in itself to walk past this painting, and one's physical relation to it, for example in the distance needed to see it as a whole within one's vision, is a major factor in experiencing it. The setting for the painting was the new, recently consecrated cemetery on a hill outside Ornans, replacing the full one in the town itself, which in the painting is on lower ground out of view between the mourners and the far cliffs; on the right is the Roche du Mont separated from the Roche du Château (Plate 23) on the left by the valley of Ru du Mambouc. The people portrayed in the picture were all local townspeople, dignitaries or friends and family of the artist, and some have been identified, most recently in *Courbet* 1977–78; the identity of the dead person remains a mystery. When the painting was sent to the Salon of 1850–51 Courbet wrote its full title in the Salon register: 'Tableau of human figures: history of a funeral at Ornans', thus indicating that he himself saw this work as falling within the tradition of history painting. But instead of recording a major historical event, Courbet here elevated to that type a particular incident in the life of the rural bourgeoisie of Ornans, recording particular characters, local topography and contemporary mores, all reflecting aspects of his home environment and therefore autobiographical; Courbet was living up to Daumier's battle cry of 'il faut être de son temps'. Contemporary critics seem on the whole to have been less divided in their opinion of this work than do present-day art historians for, with a few notable exceptions, either friends of the artist or socialists, most of them felt this painting to be a radical statement on some level. Even in purely pictorial terms the *Funeral* is unmistakably radical; its atraditional rows of figures running parallel and close to the pictorial plane, with no structured centre of focus, set it apart at a period when the public expected to have its gaze directed for it towards some centre of visual activity. To his contemporaries, Courbet's composition simply lacked unity.

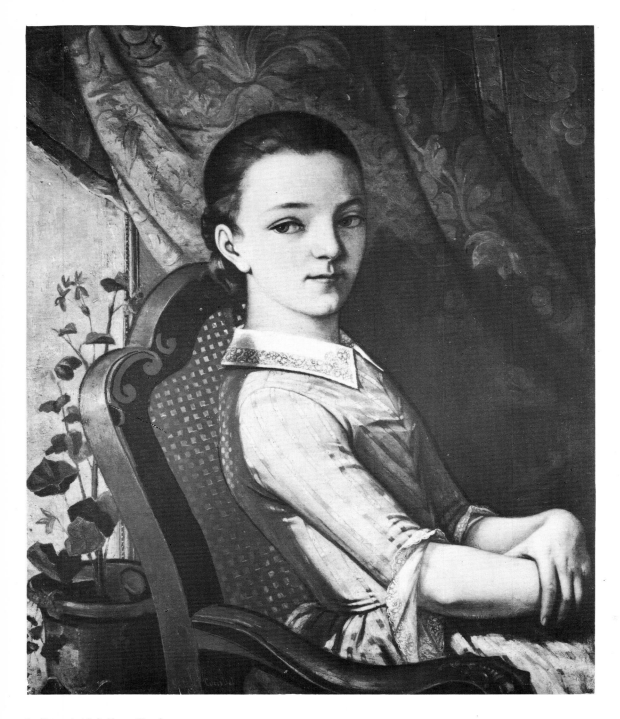

9 *Portrait of Juliette Courbet*
PARIS, Musée du Petit Palais. Signed and dated, lower centre: Gustave Courbet 1844. 78 × 62 cm.

Courbet's debt to Ingres is clearly visible in this early portrait of his youngest sister; in fact x-rays of the painting show it to have been executed over a partial copy of Ingres's *Angelica* of c. 1819 (Paris, Musée du Louvre). The strange atmosphere of this portrait may be a result of the artist's distortions of perspective; the enormous chair, dwarfing the small girl, sits at an extraordinary angle, seeming to tip the sitter almost out of the picture space. The disconcertingly frontal view of the chair's caned back is incompatible both with the angle of the chair-back itself and, behind it, with the angle of the window or 'blind' mirror at the far left. The billowing volumes of the drape above and beside the sitter accentuate the cramped, claustrophobic space of the painting, while the very detailed realism of the treatment of the girl's rich, lace-edged dress enhances the supernatural unreality of the painting. In a similar manner to his *Portrait of Paul Ansout* (**Plate 5**), Courbet's adoption of an almost 'all-over' focus in this portrait confuses the eye of the spectator in its search for the focus of interest in the composition. The shallow pictorial space seems to squash the girl's body sideways, and here the striped dress serves only to exaggerate this sensation.

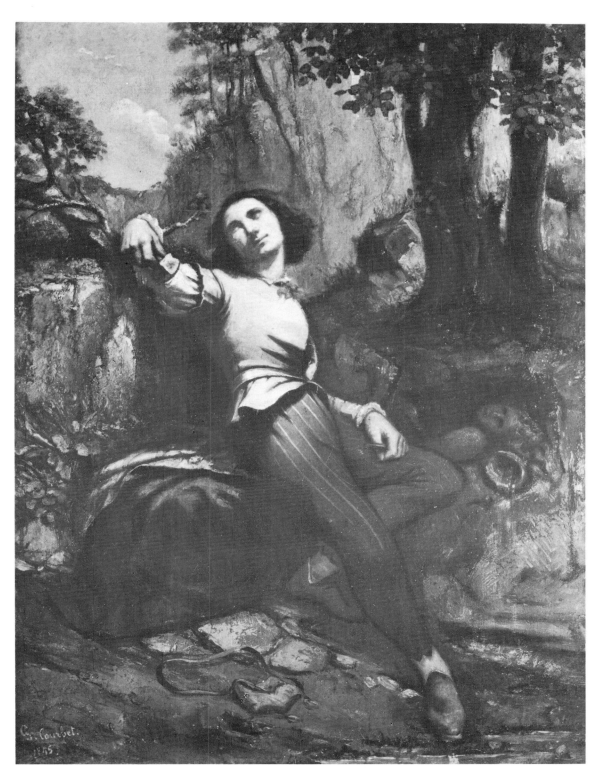

10 *The Sculptor*

NEW YORK, private collection. 1844? Signed and dated lower left: G. Courbet 1845. 55 × 41 cm.

It is now thought that, although dated 1845, this self-portrait was executed the previous year and was intended to form a pendant to *The Guitarist* (United States of America, private collection), which is dated 1844. The study, sometimes called *The Poet*, shows the artist beardless and languishing across the foreground rocks of a landscape with a spring. He holds a mallet in one hand, a chisel in the other. The picturesque medieval costume and the overall Romantic connotations of this painting show that Courbet experimented with different genres and styles of painting; this picture and the *Game of Draughts* (Plate 11) are unusual in Courbet's *oeuvre* in their use of non-contemporary costume; they reflect the interest at the period in troubadour themes and show the artist's widely varied view of his persona during the early years of his career.

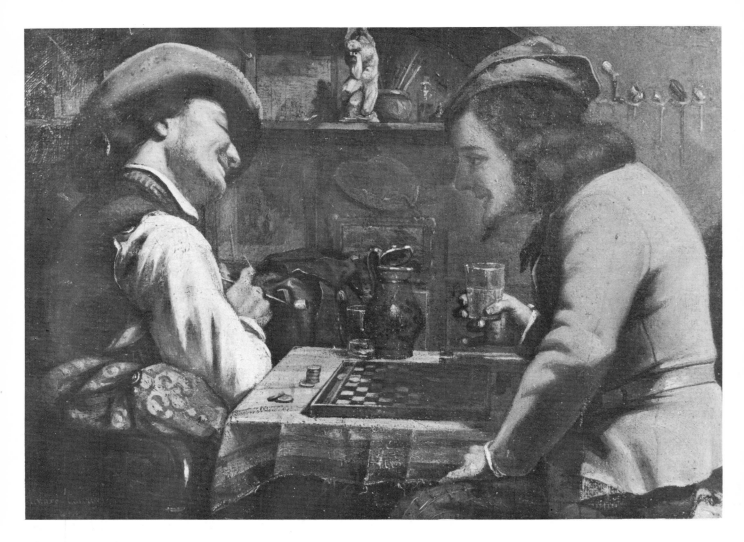

11 *Game of Draughts*
CARACAS, collection of Adolfo Hauser. Signed and dated lower left: Gustave Courbet 1844.
25 × 34 cm.

Despite the 'fantastic' element in this painting, the figure on the right of which has been identified
as a caricatural self-portrait of the artist, it shows quite realistically the interior of Courbet's studio
at that date. From 1843 the artist had used as a studio an abandoned chapel in the rue de la
Harpe in Paris, depicted here; on the wall behind the players is shown some of the artist's
equipment. A small oval palette hangs in the centre, above it on a shelf stands a plaster cast which
has been identified as one extremly popular during the nineteenth century, called 'de Michel-Ange'
('of Michelangelo'). Such casts were widely used in studios for drawing practice or in still-lifes; the
same statuette can also be seen indistinctly in Courbet's *Man with the Leather Belt* (Plate I). To the
right of the cast in the present picture is a pot holding a handful of the artist's brushes, a common
feature in nineteenth-century studio scenes; several framed pictures are visible, while on the shelf
above the broad-brimmed hat of the player on the left at least one stretcher back is visible.
Although the distance between players and background is unclear, it is apparently fairly close, and
thus the stretcher shown is rather small; despite its size the corner joints have strengthening cross
pieces which were commonly added to large stretchers to keep them rigid and square. It is
interesting to compare the stretcher shown here with the over-life-sized one visible on the far left in
Courbet's *Artist's Studio* (Plate VIII), in which the function of the corner battens makes more sense.

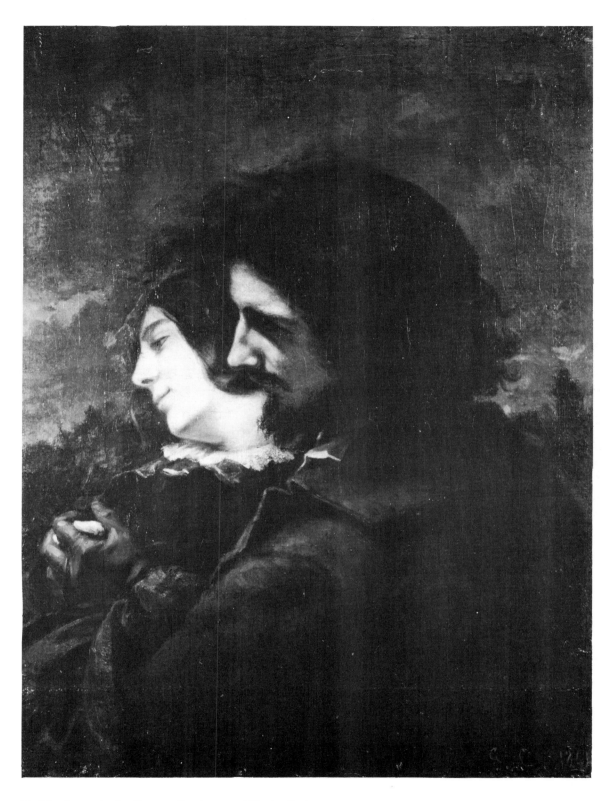

12 *The Lovers in the Country, Sentiments of Youth, Paris*
LYONS, Musée des Beaux-Arts. Initialled and dated lower right: G.C. 1844. 77 × 60 cm.

The *Courbet* 1977–78 catalogue identifies this painting as the *Walse* exhibited at the Salon of 1846, and thus the strange pose adopted by the couple becomes suddenly legible as that of dancers. The composition is dominated by the two half-length figures in the foreground, with a cursorily sketched-in landscape background. The sombre sky and deep shadows indicate a twilight scene, with the last rays of the setting sun visible at the far left. The two figures, of Courbet and probably his lover Virginie Binet, are lit from an unspecified source highlighting the flesh and casting warm shadows. The artist thus concentrates attention on the central feature of the composition.

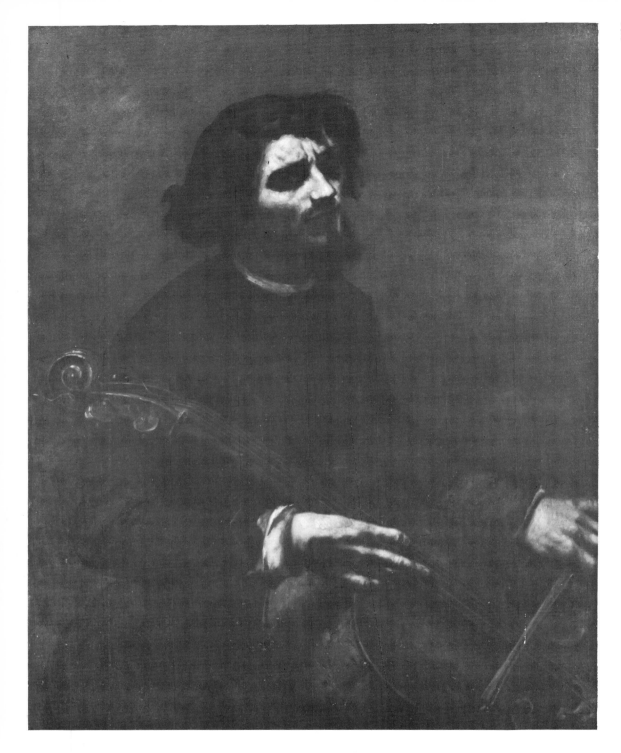

13 *The Cellist – Portrait of the Artist*
STOCKHOLM, Nationalmuseum. 1847. Initialled lower left: G.C. 117 × 89 cm.

This painting was apparently shown in the 1847 Salon as *Souvenir of Consuelo*, a title derived from a book by George Sand (see *Courbet* 1977–78), but it was only when it appeared at the open Salon of 1848, with nine other works, that the reviewers noticed it. The critic of *Le National*, Prosper Haussard, wrote on 15 June 1848: 'His *Cellist*, in particular, has qualities of style and technique, and a skill in handling and chiaroscuro, which strike you forcibly: it is like a reminiscence of Caravaggio and Rembrandt.' Courbet had evidently not sufficiently digested his influences at this date, however, as this self-portrait is not entirely successful; his use of dramatic lighting to pick out the prominent features indicates his continued interest in Romanticism, as well as in Rembrandt. The pictorial space is again cramped and unclear; were it not for the device of the left hand cut off by the canvas edge, which helps situate the figure behind the picture plane, the cellist would appear to tip forward more violently towards the spectator than he does. The form of the figure beneath his dark clothes is far less solid and powerful than the flesh passages, which Courbet treated with increasing self-confidence; the hands are perhaps the least successful of these, showing awkwardness in the modelling of the right hand especially. The left arm and shoulder are noticeably woolly and formless.

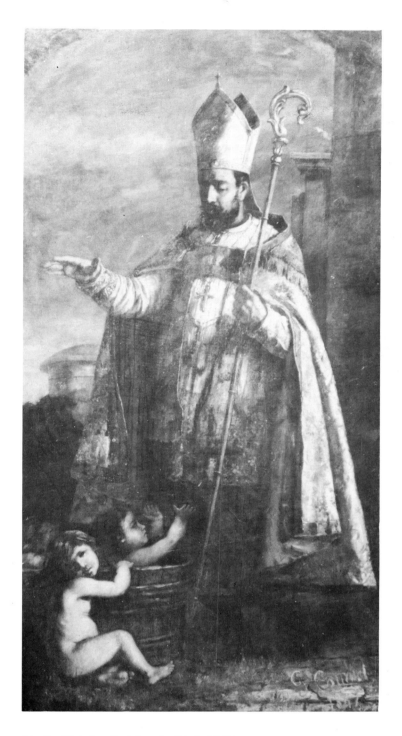

14 *St. Nicholas Reviving the Little Children*
DOUBS, Eglise de Saules. Signed and dated lower right: G. Courbet 1847. 288 × 146 cm.

Clark has identified the major source of Courbet's inspiration in this his first and only religious painting, an anonymous popular woodcut print of the late eighteenth century, *Canticle to St. Nicholas*, from the Besançon workshop of Jean Tissot. Technically Courbet owed a debt to Zurbarán in this painting, whose works he saw in the Musée Espagnol of Louis Philippe. Clark discusses these opposing influences in *Image of the People*. 'Clearly enough, Courbet is struggling to make these various "sources" work together; and equally clearly he fails. Zurbarán triumphs over the Besançon engraver; ponderous modelling replaces the [print's] ochres and greens; and where the artisan who made the print left his forms flat and separate, Courbet plods towards a rational arrangement in space; he puts enough shadow in the distant tower; he fills the background with hard-edged pilasters. In other words, the popular print is still a collector's item, a source of inspiration, not of form: its crudity is appealing, but in the end the artist corrects the obvious mistakes.' The powerful figure of Courbet's friend Urbain Cuénot, who posed for the saint and who appears undisguised in *After Dinner at Ornans* (Plate 17), dominates this large canvas; his complete containment within the limits of the canvas, with points of his body or clothes near to all four edges, creates a sense of restrained tension in the composition.

15 *Portrait of Baudelaire*
MONTPELLIER, Musée Fabre. 1847–48? Unsigned. 53 × 61 cm.

Although never finished this portrait was in an advanced stage of execution when Courbet abandoned it. Usually dated to 1849, Toussaint suggests for it a date of two years earlier on the basis that in 1847 Baudelaire cut off his long, Romantic hair and adopted the shorn look visible here. It is not known when Courbet met the writer, but they moved in the same circles in Paris and were definitely close friends by the time of the 1848 Revolution. This portrait shows Baudelaire surrounded by the attributes of his art, reading attentively; more brilliant patches of colour can be seen here than in any of Courbet's previous portraits, and the unblended application of slabs of reds and highlights on the face and neck-wear are a reminder that Courbet was highly impressed by the technical virtuosity of Frans Hals when he visited Holland in 1846.

III *Young Ladies of the Village Giving Alms to a Cowgirl in a Valley at Ornans*
LEEDS, City Art Gallery. Signed and dated lower left: G. Courbet 1851. 54 × 66 cm.

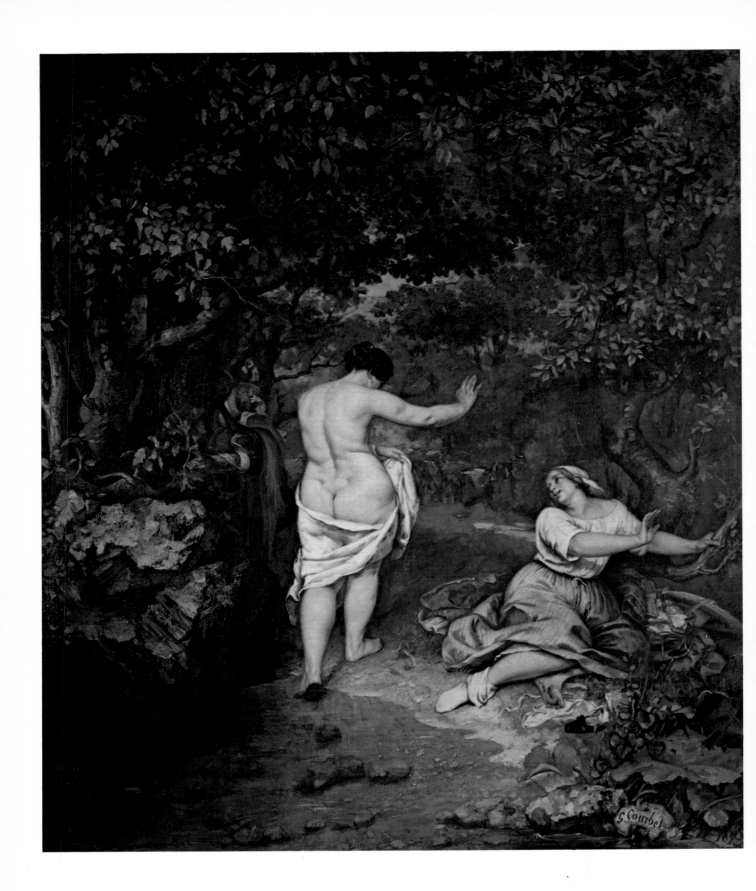

16 *La Paysanne au Madras*
UNITED STATES OF AMERICA, private collection. c. 1848. Signed lower right: G. Courbet. 60 × 73 cm.

The traditional dating of c. 1858 has been revised by Toussaint to the early dating of 1848 on the basis of the style of the landscape at the right of the composition, which derives from Jacob Ruisdael and the Barbizon school of landscapists who looked to the seventeenth-century Dutch artist for inspiration. The gentle, pensive air of this peasant girl harks back to the work of Chardin, while in a contemporary vein links to the rustic peasant novels of George Sand. The 'close-up' view of this girl, her body placed off-centre of the composition, gives the impression of a portrait rather than a genre painting. An identification of the model here with Juliette Courbet has been suggested, but a comparison with the portrait of four years earlier (Plate 9) with its pale-complexioned sitter makes this unlikely. Juliette's eyes in the portrait are large, blue and protruding and her ear has a distinctively long fleshy lobe; in *La Paysanne au Madras* the girl has dark, rather deeper set eyes, a more angular nose and an almost non-existent ear-lobe. The forehead of Juliette in her portrait is much deeper than the woman's in this painting, and her chin more sharply pointed.

IV *The Bathers (Women Bathing)*
MONTPELLIER, Musée Fabre. 1853. Signed and dated lower right: G. Courbet 1853. 227 × 193 cm.

As has been widely documented, *The Bathers* caused a scandal at the Salon of 1853; both Champfleury and Delacroix noticed and recorded the fact that the woman was a bourgeoise, elsewhere she was stated to be in her forties, though this seems an exaggeration. Lindsay analyses some of the reasons for the nude's scandalous impact at the period: 'The smooth graceful nude of the academics, in which sexual life was minimised or diverted into sly innuendo, represented for Courbet an important aspect of the bourgeois lie and distortion he was attacking all along the line. His big naked woman was an anti-academic image, directed against all the prevailing hypocrisies ... But because of Courbet's love of life the image is ambivalent; he glories in every crease and ounce of the huge body.' While this analysis gives an over-simplified impression of the aims and complexities of Courbet's nudes, it is informative to compare his portrayal of them with that of his contemporaries; it is significant that this heavy, unidealized figure is posed in a classical *contraposto* with her right arm raised in a similarly classicizing gesture. Thus Courbet presented his audience with an 'ideal' pose which conflicted with and emphasized the realism of the huge naked figure; her towel, which is a reminder of the classical drape, reinforces this conflict, as does the ambiguity of the clothed woman on the right. Usually described as the naked woman's servant because of her unsophisticated dress, she also adopts a classicizing pose which echoes and balances that of the standing figure; but her drooping stocking was hardly an attribute of the ideal. Courbet is known to have used photographs to aid the execution of several of his paintings, for instance *The Artist's Studio* (Plate VIII), *Woman with a Parrot* (Plate 63) and *The Château de Chillon* (Plate 81), as did many of his contemporaries, including Ingres and Delacroix, and Scharf puts forward a convincing example which Courbet may have used for the nude in this painting.

17 *After Dinner at Ornans*
LILLE, Musée des Beaux-Arts. 1848–49. Unsigned. 195 × 257 cm.

Painted in Paris during the winter of 1848–49, *After Dinner* was shown at the Salon of 1849, where it received a second-class Gold Medal. The stylistic and compositional sources for this picture which have been identified by a number of art historians are many and complex; they include Rembrandt's *Supper at Emmaus* of 1648 (fig. 13), Louis Le Nain's *Peasant Meal* of 1642 (Paris, Musée du Louvre, then probably in the collection of I a Caze and accessible to visitors), Velázquez's *Supper at Emmaus* of 1628–29 (fig. 11; a copy, then thought to be by Velázquez, was in the Musée Espagnol), Grosclaude's *Toasting the Wine Harvest of 1834* (Digne, Musée Municipal, but then in the Musée du Luxembourg in Paris), Caravaggio's *The Calling of St. Matthew* of c. 1601 (fig. 12). The style is also seen as close to that of his friend Bonvin, though the latter painted with none of the powerful simplicity and scale of *After Dinner*. What is evident here, however, is the independent strength of Courbet's painting, for despite the variety of its possible sources, the final product is distinctively new and original, showing that Courbet had absorbed the art of the Old Masters and was no longer directly dependent upon them. The painting is worked in a sombre palette reminiscent of Rembrandt, but the overall tonality has darkened considerably since it was painted because of Courbet's habitual overuse of the cheap but dangerous pigment bitumen. The composition contains four figures, from left to right, the artist's father, Régis Courbet; Urbain Cuénot, the host, often misidentified as a self-portrait of Courbet; one of the Marlet brothers, friends of the artist; finally Alphonse Promayet, playing the violin. The scene has been identified as an afternoon one, rather than evening, dinner being then a midday meal and the darkness of the room caused by the lateness in the year, November, when the event took place. This is the first of Courbet's great Realist history paintings, in which he recorded on a monumental scale hitherto almost exclusively reserved for 'noble' events, the activities of the rural classes at a particular moment in history.

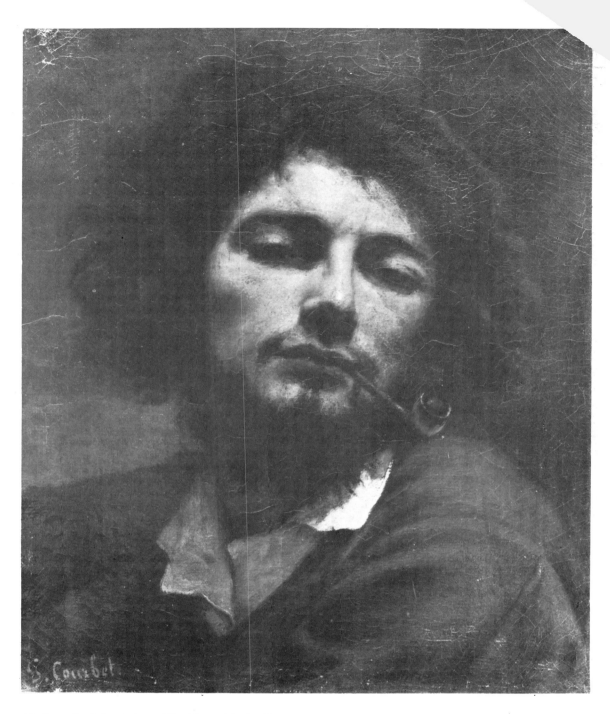

18 *Portrait of the Artist – The Man with the Pipe*
MONTPELLIER, Musée Fabre. 1848–49? Signed lower left: G. Courbet. 45 × 37 cm.

Dated by the painter himself to 1846 in the catalogue of his one-man show of 1867, this has been doubted by several writers since then; Courbet often forgot or misdated works when writing about them, as he also had the habit of dating the paintings themselves with the year of their exhibition rather than execution. He frequently attacked unjustly the workings of the Salon jury which, while it did reject works by him regularly, particularly during the 1840s, was not as infamous towards him as his pride and paranoia convinced him it was. This portrait, he maintained, had been refused at the Salons of 1846 and 1847 'by the jury composed of members of the Institut'; in fact records show that it appeared for the first time at the Salon of 1850–51, where it was noticed and admired by Louis Napoleon himself. Although in treatment owing much to Guercino, the prototype most obviously used here is *The Smoker* (Paris, Musée du Louvre, then in the La Caze collection) thought to be by the seventeenth-century Flemish artist Adriaen Brouwer, but now attributed to Craesbeck. The artist's eyes are down-cast and deep in shadow, the sensuous fullness of his lips and the dark curl of his nostrils showing us yet another aspect of the artist in his search for a painterly identity. The sobriety of his limited palette is relieved by the warmth of the flesh tints, the red of the lips in particular working in contrast to the rich blue-green of the jacket, a colour which was evidently a favourite of Millet and appeared regularly on his peasants' clothes, for example the leggings of *The Winnower* of 1847–48 (United States of America, private collection).

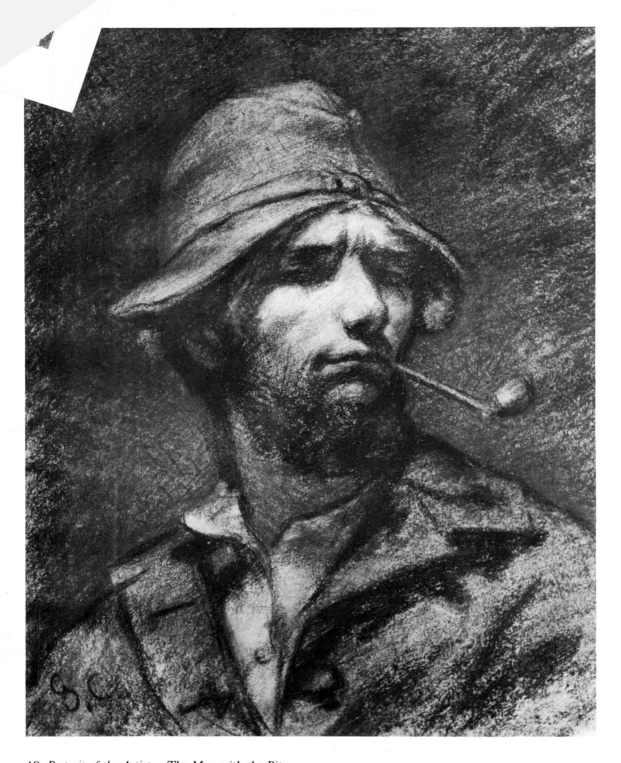

19 *Portrait of the Artist – The Man with the Pipe*
HARTFORD, Wadsworth Atheneum (J. J. Goodwin fund). c. 1849. Charcoal heightened with white chalk on paper. Initialled lower left: G.C. 27·9 × 20·6 cm.

There is a similarity between the expression in this drawing and in the oil self-portrait (Plate 24), although the drawing seems more overtly and self-consciously bohemian, showing the artist cockily posed in his hunting gear. There are obviously links also with the oil variant (Plate 18), although there is no reason to believe that this drawing is a study for it; in fact its greater degree of independence from earlier masters and its rugged, uncompromising handling of the subject most likely date it later than the oil. In the drawing the relationship between figure and paper format places the artist higher and further off than in the oil, in which Courbet seems to lean out towards the spectator; here he appears more aloof, self-contained, almost as if viewed from below with his head held well up. The charcoal is heavily worked to create a chiaroscuresque rendering not dissimilar to the oil variant, exploiting the inherent properties of the rich charcoal medium to the full.

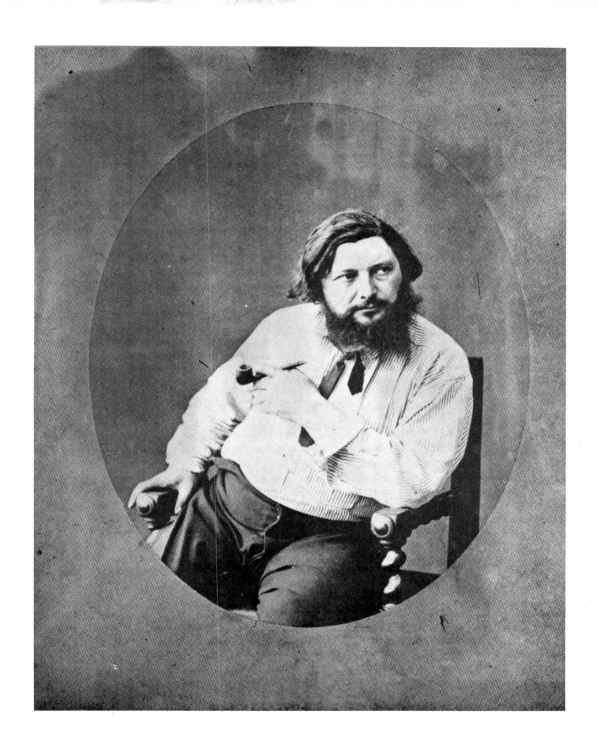

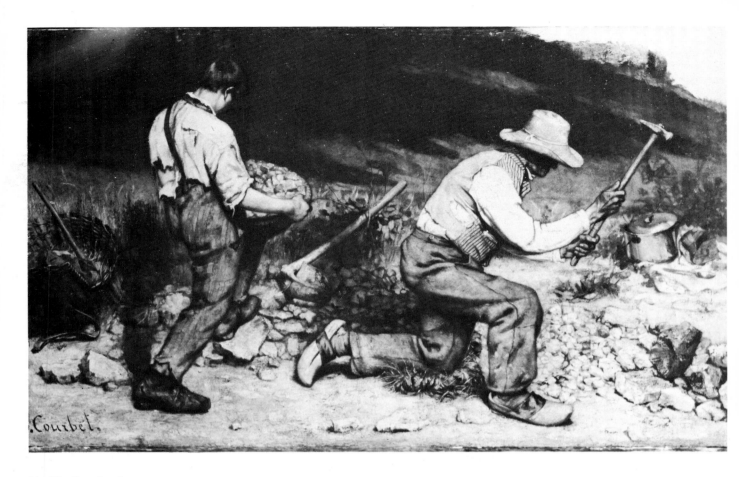

21 *The Stonebreakers*
formerly DRESDEN, Staatliche Gemäldegalerie, destroyed in 1945. 1849. Signed lower left:
G. Courbet. 165 × 238 cm.

This is the first of Courbet's three great Realist canvases of 1849–50, the other two being the
Funeral (Plate II) and *Peasants of Flagey Returning from the Fair* (Plate 37). Although not a particularly
rare subject (for example Millet depicted *roadbuilders,* fig. 15), Courbet's interpretation of it, to
quote Nochlin (*Realism*, 1971), was 'the most graphically direct and startlingly unvarnished image
of contemporary work of the entire century or, indeed, in the entire history of art.'

22 *Funeral at Ornans*
BESANÇON, Musée des Beaux-Arts. 1849–50. Unsigned. Charcoal on bluish paper. 37 × 95 cm.

This a surprisingly large preparatory drawing for the finished oil (Plate II), but considering the size
of the final work, Courbet's choice of scale for the drawing makes sense. Numerous subtle and
major differences can be seen between the two works, all of which help towards an understanding
of the processes involved in Courbet's Realist style. In the drawing there are only hints at the
dramatic use of colour which the artist was to evolve in the painting, the right side of which in
particular is dominated by large areas of black, out of which the faces of the women mourners
stand in stark contrast. This is one of the largest and most finished surviving drawings by Courbet;
a head-count of the figures included, although some are indistinct, suggests that this original
conception intended the inclusion of more figures, forty-eight, rather than the final forty-six in the
oil.

23 *Château of Ornans*
MINNEAPOLIS, Minneapolis Institute of Arts (John R. Van Derlip and William Hood Dunwoody
funds). c. 1850? Signed and dated lower right: G. Courbet 55. 81 × 117 cm.

The rather late date on this painting probably indicates that it was signed the year it appeared in
the Paris Universal Exhibition. The hamlet named in the title is the same as that just visible high
on the cliff to the left of the *Funeral* (Plate II) and was built on the ruins of a medieval fortress.
This landscape is similar in handling to the Leeds version of *Young Ladies of the Village* (Plate III),
although perhaps less confident; the open, undistinguished panorama, derived from English
eighteenth-century precedents, was a feature of Courbet's early landscapes. They were soon to
become dominated by the dense, lush forest views, as early as 1853 with the setting for *The Bathers*
(Plate IV) so different in character and claustrophobically enclosed in atmosphere.

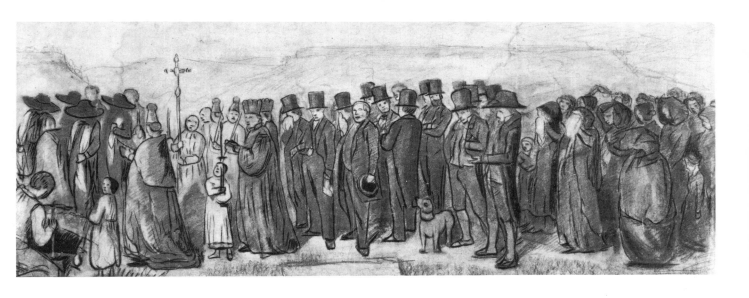

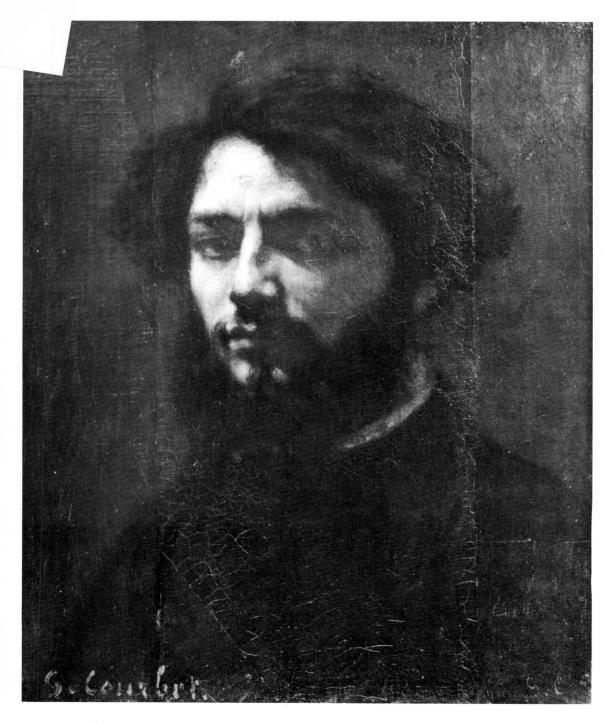

24 *Portrait of the Artist*
BESANÇON, Musée des Beaux-Arts. 1849–50. Paper laid down on canvas. Signed lower left: G.
Courbet; initialled lower right: G.C. 50 × 40 cm.

De Forges corrects the misidentification of this portrait with the one exhibited at the Salon of 1846
(Plate I) and points out Delbourgo's discovery that it was made up of five pieces of canvas. De
Fourges suggests that the portrait may have been cut from a larger painting, now obviously lost,
and she indicates that the support was of paper laid down on canvas, presumably referring to the
central, vertical panel of the support, as elsewhere the canvas grain is quite clearly visible.
Delbourgo and Faillant do not mention the use of paper in the support, but publish an x-ray of
the painting which reveals a fragment of an earlier work, an unfinished copy after Ingres's *Roger
Delivering Angelica* (Paris, Musée du Louvre), on the central panel of canvas beneath the portrait.
From the x-ray it appears that there are four rather than five pieces of canvas constituting the
support. The canvas grain is fairly fine in texture and weave, and on the panels to the sides of the
paper the painting is only lightly worked by comparison to the central area. The Spanish
inspiration and directness of treatment which Courbet saw at the Musée Espagnol of Louis
Philippe dominate this assertive self-portrait, one of Courbet's most vigorously straightforward to
this date. The sombre, Byronic intensity of regard and the dramatic light and shade were still
Romantic in origin, but show a greater maturity in the overall emotional restraint of the painting.

25 *Toilet of the Dead Woman*, generally known as *Toilet of the Bride*
NORTHAMPTON (MASSACHUSETTS), Smith College Museum of Art. c. 1850. Unsigned. 188 × 251 cm.

In a superb piece of art historical detective work and observation, Hélène Toussaint has unravelled the original subject of this painting which has, since the studio sale of 1919, ironically been known as a toilet of the bride, rather than the real, macabre scene of preparations for a wake. Toussaint suggests (*Courbet* 1977–78) that the unfinished painting was judiciously altered to disguise its true identity, for fear that at the sale its value would have been disadvantageously affected by such a subject. X-rays indicate a naked and limp central seated figure, the corpse, the clothes and mirror and more lively disposition having been added by a forger. With this knowledge of its original subject the composition suddenly makes sense; the cool palette dominated by blues and greens used here by Courbet suit more accurately the atmosphere of mourning than of marriage.

26 *Portrait of Hector Berlioz*
PARIS, Musée du Louvre. 1850. Signed and dated lower left: 1850 G. Courbet. 61 × 48 cm.

This sober, unhappy portrayal of the composer may date from a year or two prior to Courbet's dating on the canvas; as was his habit, he often gave the date when the work was exhibited, this time at the Salon of 1850–51. The painting has stylistic and emotional similarities to Delacroix's portrait of Chopin of 1838 (Paris, Musée du Louvre), although the latter is more flamboyant in its Romanticism and the Berlioz portrait darker and more sombre in tonality. As an image it is also much less crisp and decisive than Courbet's self-portraits of the period, but it shows a growing originality in Courbet's work with less reliance on the Old Masters.

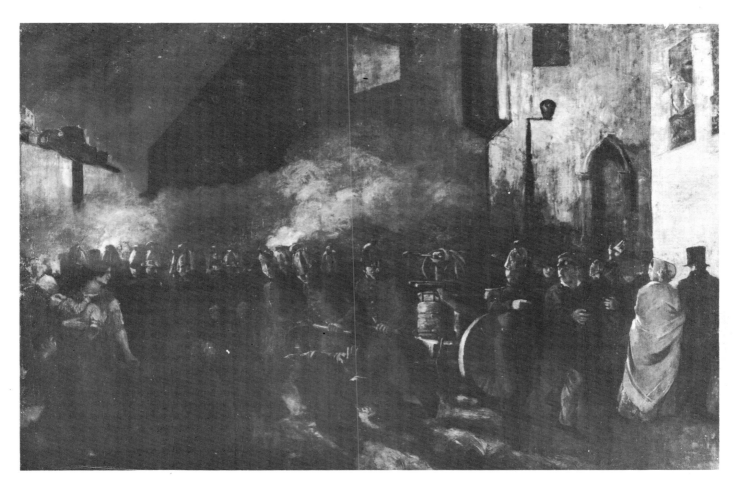

27 *Firemen Going to a Fire*
PARIS, Musée du Petit Palais. 1850–51. Unsigned. 388 × 580 cm.

This enormous, unfinished canvas was Courbet's only attempt to produce an urban equivalent of his great *Funeral* (Plate II). Tim Clark discusses (*Image of the People*) the abortive evolution of the painting: 'Why it was never finished is not clear. Tradition has it that the *coup d'état* [of December 1851] intervened; but Courbet rarely took a year to block in a picture, even on as vast a scale as this. It seems to me the difficulties were internal, that the *Firemen* is a failure rather than a misfortune. And perhaps the state of the canvas, with its figures no more than blocked in over a thick ground of black and mid-brown and grey – a ground which shifts in colour, through a narrow range, over the whole picture surface – is in the end appropriate to the matter portrayed. Courbet never did paint the epic of modern life in the city... It is as if in this picture the matter of city life remained too dense and alien and complex to be articulated in the same way as the *Burial at Ornans*.' The fact that this painting was caricatured unseen by Bertall in the *Journal Pour Rire* of 7 March 1851, even though it was not in the Salon, would seem to confirm that it was by then already well advanced, and that it was abandoned prior to the events of the following December. Links with Rembrandt's so-called *Night Watch* of 1642 (Amsterdam, Rijksmuseum), particularly in the posing of individual figures and in details, and with the painterly techniques of Hals have been drawn in discussions of this painting, although in Courbet's composition the complexity and sense of space used by Rembrandt were replaced by a more shallow space and a linear disposition of the figures, closer in feeling to the *Funeral*. The pictorial space in *Firemen Going to a Fire* is in fact very enclosed for an outdoor scene; the darkness of the night setting and the billowing steam from the fire-pumps cut off any depth beyond the foreground figures, while the solid blocks of architecture to the right, the left and above further cramp the scene. The close-ranked array of firemen, echoing the lines of mourners in the *Funeral*, is enlivened by the poor woman with her child to the left, the half-fallen man with palm outstretched near the centre, the two gesturing fire officers and the retreating bourgeois couple to the right.

28 *Young Ladies of the Village Giving Alms to a Cowgirl in a Valley at Ornans*
NEW YORK, Metropolitan Museum of Art (gift of Harry Payne Bingham). 1851. Signed lower left:
G. Courbet. 195 × 261 cm.

The oil sketch (Plate III) for the final version (Plate 28) presents a quite different composition from and is considerably smaller than the New York picture; both were finished before the *coup d'état* in December, and the larger painting was shown at the Salon of 1852 where it was bought by the comte de Morny. In the Leeds sketch the landscape dwarfs the small group of Courbet's three sisters, Zoé, Zélie and Juliette, and the cowgirl, who appear to be placed on the floor of the valley. The final version shows the women much closer to the spectator, now raised up in relation to the landscape as if on the brink of the valley. This transformation serves to exaggerate in the New York painting the awkward relation between figures and landscape; although the proportions in the sketch are also uncomfortable (the size of the cows makes no sense beside that of the women), the idiosyncrasies are less prominent because of the smallness of the figures. The final version indicates that Courbet in fact wanted to emphasize these characteristics; the landscape is no longer straightforward to read as the space between foreground and distance is fractured and left ambiguous, the relative disproportions of figures and animals is stronger, and Courbet intentionally created an uneasy image close to that of his large figure paintings. Even the space-defining tree of the first version was painted out in the later one, and this can still be seen, particularly in the sky above and to the right of the women. The rather harsh, bare landscape is in the same character as that of the *Château of Ornans* (Plate 23), although in the *Young Ladies* the Lorizon has been brought much closer to the spectator, hemming in the figures and eliminating a vanishing point to concentrate the eye on the foreground scene. In the final version all the figures and animals were rendered with the same attention to detail, with the same sharp clarity of brushwork, giving the painting the 'all-over' focus characteristic of Courbet's Realism.

29 *The Return to the Country (Homecoming)*
PARIS, private collection. c. 1852? Signed lower left: G. Courbet. 81 × 64 cm.

Toussaint suggests this may be a portrait of Courbet himself (*Courbet* 1977–78), and the dramatic gesture and the extent to which the figure dominates the composition may confirm this. The title of the painting, too, seems very autobiographical in view of the pleasure and frequency with which the artist returned to his native Ornans.

30 *The Sleeping Spinner*
MONTPELLIER, Musée Fabre. 1853. Signed and dated lower left: G. Courbet 1853. 91 × 115 cm.

This painting and *The Bathers* (Plate IV) were the first of Courbet's pictures acquired by his patron and soon close friend Alfred Bruyas (1821–1877), when they appeared, with *Wrestlers* (Budapest, Szépmüvészeti) at the Salon of 1853. This is a superbly rich painting in which Courbet evidently delighted in the treatment of fabrics of varied textures and patterns; his recurrent use of striped material is apparent, although here exploited more for its lush, sensuous qualities than for its ability to define form. The model was placed off-centre in this composition, balanced by the still-life of spinning wheel and flowers to the left; both in subject and palette *The Sleeping Spinner* is reminiscent of Dutch genre paintings of the seventeenth century. The vulnerability of the sleeping woman is again an important element in the emotional temperature of the image, as for instance in the *Sleeping Blonde* (Plate 20), *Women Asleep* (Plate XI) and *The Awakening* (Plate 62); the gentle angle of the spinner's head has cast her face into warm shadow and left the highlight falling on the soft flesh of her plump neck, which forms the lightest area of the canvas and directs the eye towards it. Courbet's subtle organization of her submissive pose is perhaps the more appealing as she is shown fully clothed. This is not a painting of his sister Zélie, as has been suggested, but was in fact posed by a cowgirl.

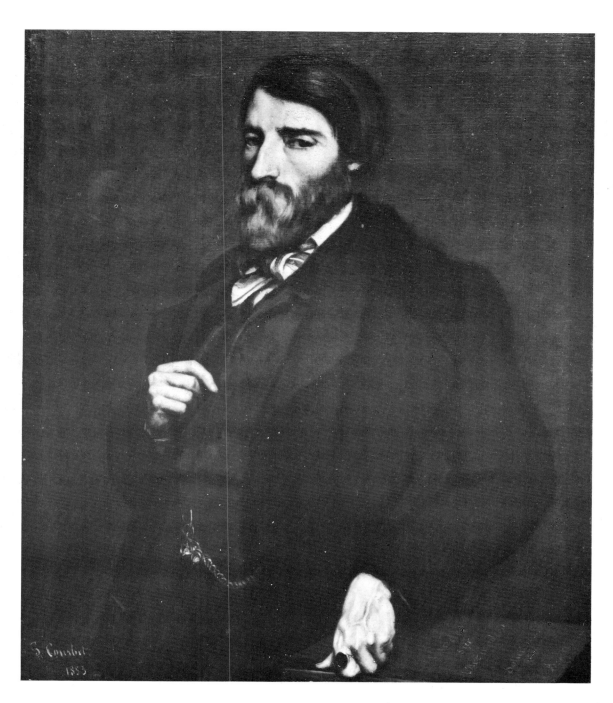

31 *Portrait of Alfred Bruyas*
MONTPELLIER, Musée Fabre. Signed and dated lower left: G. Courbet 1853; annotated lower right on the book: *Etudes sur l'art moderne. Solution. A. Bruyas.* 91 × 72 cm.

Having acquired two major paintings by Courbet at the Salon of 1853 (Plates 30 and IV) Alfred Bruyas commissioned this portrait from the artist, which was posed in Courbet's Paris studio. Thus began a close friendship with this Montpellier collector and patron of the arts who was to do much to aid Courbet. This is one of the most successful portraits of Bruyas, whose collection contained a large number painted by a wide variety of artists, including Delacroix; one senses that the sitter's preoccupation with himself must have struck a chord of sympathy with Courbet, whose numerous self-portraits indicate a similar concern with his self-image and an underlying quest for self-knowledge in an age of uncertainty and change. This is a forceful portrait in the grand European tradition; the strength of the sitter is emphasized by the powerful profile of the nose and the intense gaze of his deep-lidded eyes. The positioning of the figure in the picture space, raised almost to the full height of the canvas, has the effect of lifting him above the spectator, increasing his stature and presence. The irregular, rather coarse weave of the canvas is clearly visible particularly in the top part of the canvas and to the right of Bruyas's head; it is interesting to note that the horizontal threads of the canvas can be seen to slope down towards the left edge, indicating that the canvas was probably not stretched square to its support. The book on which Bruyas's left hand rests is a reference to his *Solution d'artiste. Sa profession de foi* which was published in 1853 and which is discussed in the essay by Alan Bowness in *Courbet* 1977–78.

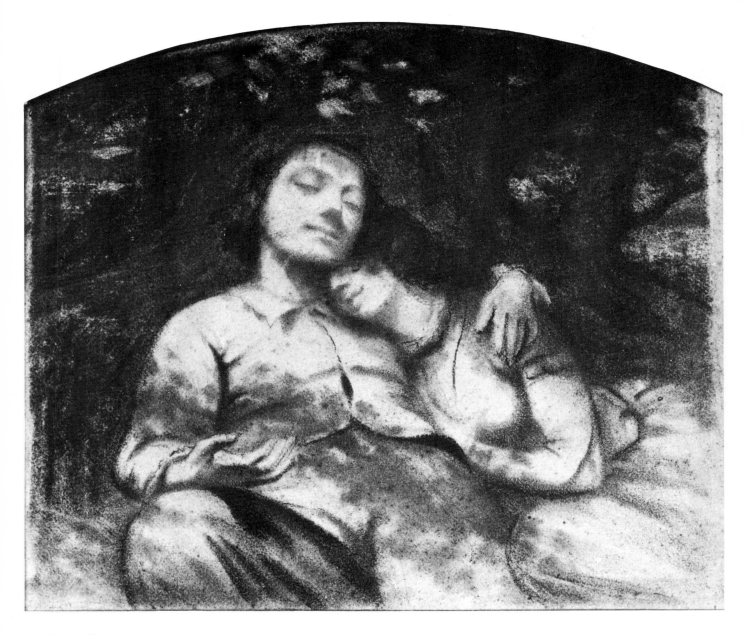

32 *Country Siesta*
BESANÇON, Musée des Beaux-Arts. Before 1849. Unsigned. Charcoal or black crayon on paper with curved top 26 × 31 cm.

This drawing has been variously dated at between 1840 and as late as 1854; de Forges suggests a dating of c. 1840–44, while most recently Toussaint posits a date of after 1849 on the basis of the competence of the draughtsmanship. She also puts forward the idea that it may be contemporary with the final reworking of *The Wounded Man* (Plate 33) in 1854, as a record of the composition thus painted out. I feel that, by comparison to Courbet's drawing for the *Young Ladies on the Banks of the Seine* (Plate IX), reproduced in de Forges as no. 8, *Country Siesta* is a far more youthful and awkward drawing and would tend to date it to well before rather than after 1849. This is again a self-portrait, probably showing the artist with his mistress Virginie Binet. This drawing is similar in theme to *The Large Oak* (Plate 6) and shows the composition of the second painting underneath *The Wounded Man*. It may have been a study for this obliterated work.

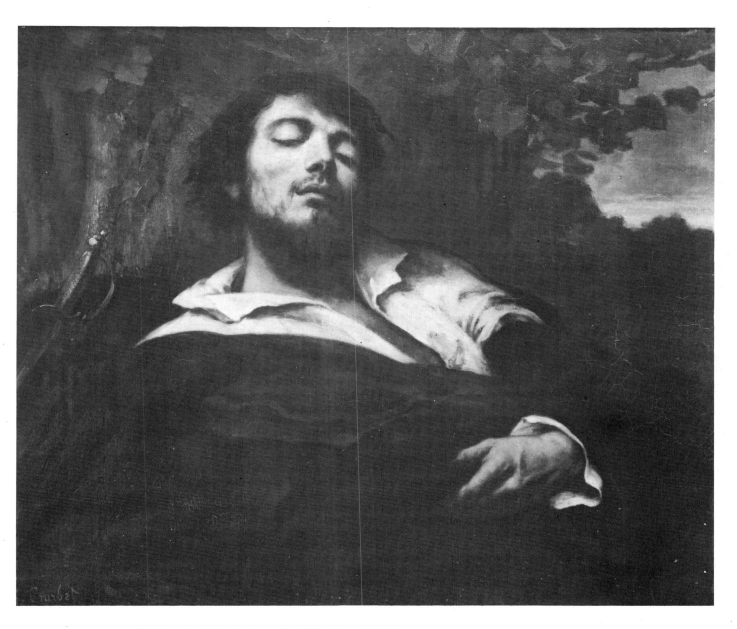

33 *Portrait of the Artist*, called *The Wounded Man*
PARIS, Musée du Louvre. 1844–54. Signed lower left: G. Courbet [spurious]. 81 × 97 cm.

It is apparent from x-rays made by the Laboratoire de Recherches des Musées de France (fig. 6)
that there are two earlier paintings beneath the present one; the one immediately beneath *The
Wounded Man* is close in composition to the drawing *Country Siesta* (Plate 32), while the first painting
is more complex and is discussed in full on p. 28. Toussaint suggests in *Courbet* 1977–78 that the
repainting of the final picture, which eliminated the lover from the composition and turned the
sleeping man into the present one close to death, coincided with the marriage of Courbet's mistress
Virginie Binet in 1854. Thus the single wounded figure of Courbet in this painting becomes a
visual metaphor for his sadness at the loss of his woman and their son; according to Courbet
himself the couple had been together for fourteen years.

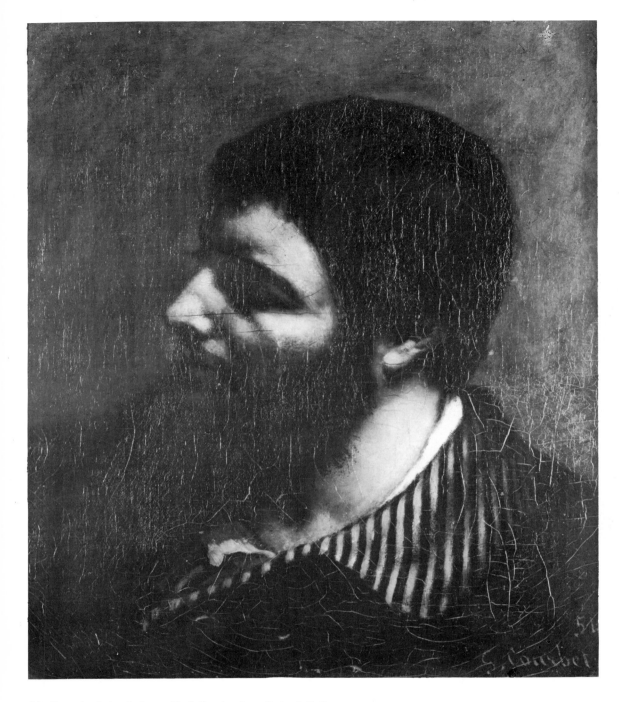

34 *Portrait of the Artist*, called *Courbet in a Striped Collar*
MONTPELLIER, Musée Fabre. Signed and dated lower right: 54 G. Courbet. 46 × 37 cm.

This portrait was painted during Courbet's stay with Bruyas in Montpellier in 1854, showing a similar though less complete profile than in his self-portrait in *The Meeting* (Plate V), with the artist wearing the jacket with the striped collar seen on Bruyas in that painting, he evidently borrowed it from the collector. This powerful profile was called by the artist his 'Assyrian' profile; recent excavations had revealed to the Western world the art of Nineveh, and Courbet noticed with pleasure the similarity of this view of his face to images on Assyrian reliefs. This painting provided the basis for his self-portrait in the *Studio* (Plate VIII), and the dramatic tracing for transposing the image to the large canvas has survived and is reproduced in de Forges as no. 51. It is significant to note yet again Courbet's love of striped fabrics, used here for the richness of texture and visual stimulation they add to the composition.

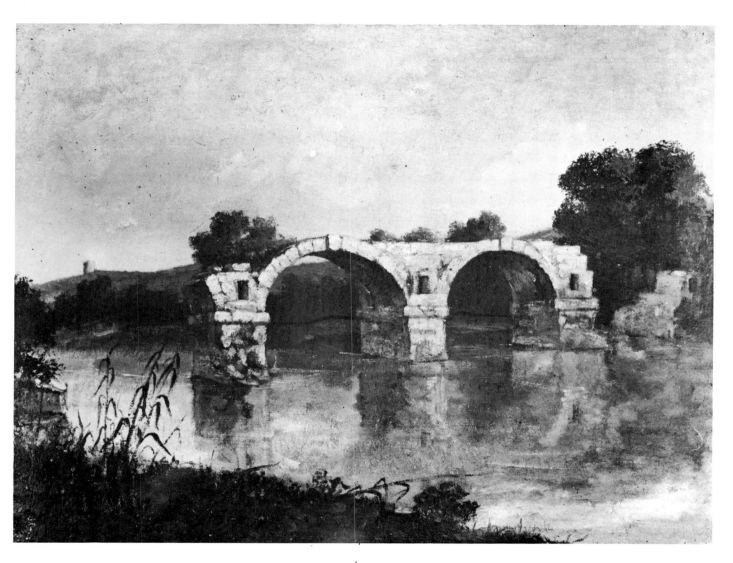

35 *Ambrussum Bridge*
MONTPELLIER, Musée Fabre, 1854 or 1857. Unsigned. Inscription on back in hand of François Sabatier: Vue du Pont d'Ambrussum sur le Vidourle par Courbet durant son séjour chez moi. Paper laid down on panel 43 × 68 cm.

Toussaint points out that it is not known when exactly Courbet visited Sabatier (*Courbet* 1977–78); it may have been on his first visit to Montpellier in 1854 or his second in 1857. This painting has a rather Corotesque motif and is on quite a large scale for a study on paper; the particular texture of oil on paper is clearly visible. The Romantically inspired theme of ruins is reminiscent of his work in that vein from the 1840s and is not a feature of his mature landscape style. The different textures in the painting are carefully evoked, but the balancing and spatial device of the details in the foreground, the reeds in particular, seem affected.

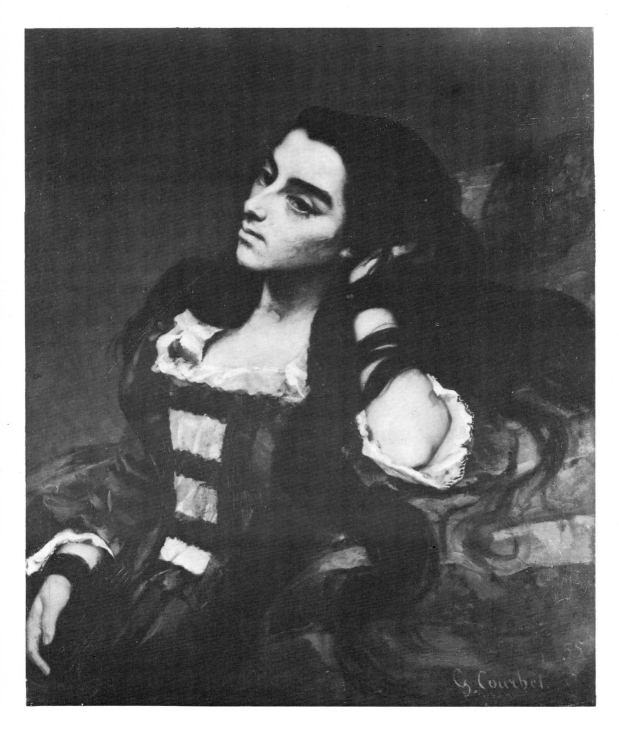

36 *A Spanish Lady*
PHILADELPHIA, Philadelphia Museum of Art (John G. Johnson collection). 1854. Signed and dated lower right: G. Courbet 55. 81 × 65 cm.

Although dated 1855 for the Universal Exhibition of that year, this fine portrait was painted in the late summer of 1854, after Courbet left Montpellier and while he was staying at Lyons before his return to Ornans. Courbet's love of long, flowing hair is amply demonstrated by *A Spanish Lady*; hair was a major element of sexual attraction in the nineteenth century, for which the Pre-Raphaelite painters in England were well known. In France, too, there were many followers of this vogue, including Renoir later in the century, and Courbet was a major exponent of the attribute, with most of his luscious women and nudes sporting prominent and beautiful heads of hair, particularly in the *Portrait of Jo, the Beautiful Irish Girl* (Plate 60).

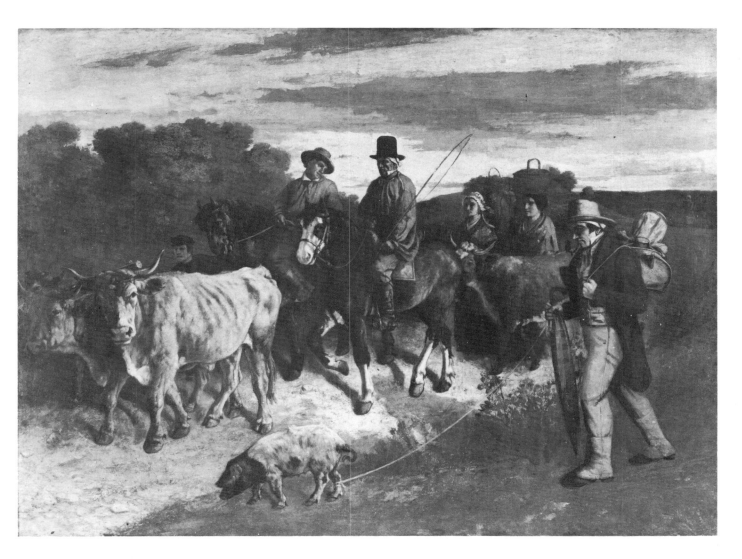

37 *Peasants of Flagey Returning from the Fair (Ornans)*
BESANÇON, Musée des Beaux-Arts. 1850–55 Unsigned. 206 × 275 cm.

The original painting, which was shown at the Salon of 1850–51, has disappeared; the present
picture is a second version painted some time before 1855 when it appeared at the Universal
Exhibition. The Besançon painting is wider than the original, as Courbet mentioned in a letter
concerning the new version; he also altered the positions of some of the figures as he was criticized
at the Salon for the picture's lack of perspective. While this was not an uncommon theme at this
period, Courbet's rendering of it seems deliberately inconsistent and ugly spatially; Clark discusses
this (*Image of the People*): 'In terms of pigment pure and simple, no picture could be more consistent;
the same weight is given to the gleaming flanks of the cows as to the chalky path below them;
foliage, shawls, crude silk, are all painted in the same thick impasto. But when it comes to placing
figure against figure in space, no picture could be more erratic. The man with the pig strides a
separate landscape from the line of cattle behind him, his head and shoulders awkwardly repeated
– and hardly diminished – by the woman in the blue-green shawl. The space between the two
parts of the picture is absolute, absurd ... Courbet's man with the pig steps out of this [picturesque]
dream. He *dates* the picture, announces the nineteenth century. No wonder he became the focus of
the critics' wrath.' The man with the pig was a late addition to this composition which, while
echoing rural peasant scenes from Dutch seventeenth-century painting, in fact breaks with all
traditional representations of the peasant. Perhaps the distortions, which were meant to jolt and
shock, were for Courbet symbolic of the awkwardness felt by the French people in their attempts to
adjust to new social and class rôles.

38 *Bouquet of Flowers*
HAMBURG, Kunsthalle. Signed and dated lower left: 55 G. Courbet. 84 × 109 cm.

Courbet painted few still-lifes of flowers before the 1860s (Plate 50); in this large composition the flowers almost fill the picture surface, with branches reaching to all four edges of the canvas. A shallow, box-like pictorial space is created by the tonal geometry of the bouquet's setting, and the richly textured rendering of the flowers brings them forward even further towards the spectator; this is also emphasized by the steep angle of the table (?) upon which the bouquet rests.

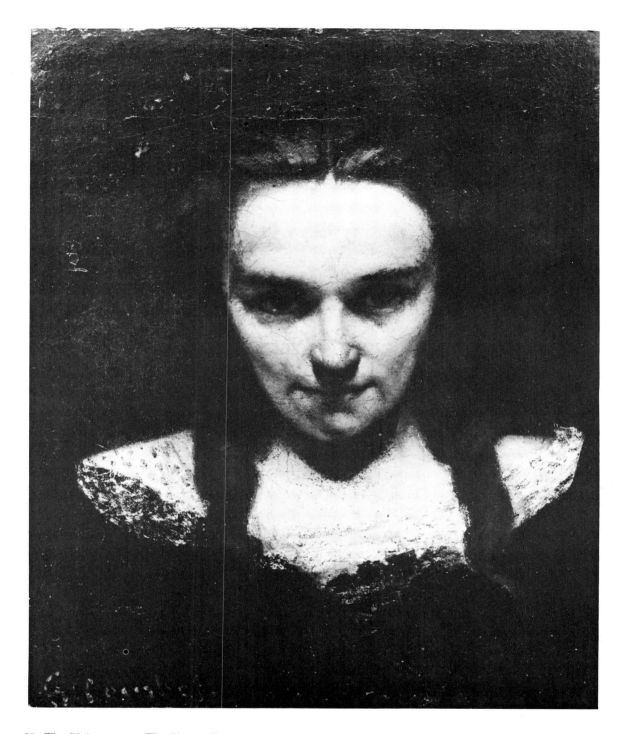

39 *The Clairvoyant* or *The Sleepwalker*
BESANÇON, Musée des Beaux-Arts. 1855? Signed and dated lower left: 65 G. Courbet. 47 × 39 cm.

Toussaint suggests (*Courbet* 1977–78) that this painting was post-dated by several years, and that this is the work that was exhibited in 1855 and was therefore executed by that date. The signature and dating do appear to have been painted in different sizes of brush, which may indicate that the date was added at a different and possibly later time. The powerful and hypnotic gaze of the sitter, who may have been the artist's sister Juliette, is reminiscent of Courbet's early self-portrait such as *The Desperate Man* (Plate 7) in its emotional intensity. The rich, sombre chiaroscuro and dazzling highlights serve to emphasize this force and almost push the woman out of the picture plane at the spectator; the dramatic lighting falls from above casting the woman's eyes into shadow and leaving dark shadows on her mouth and neck, the thrusting, blank expanse of her forehead reinforcing the forward movement of her head, led by her dark penetrating eyes. Courbet's penchant for painting women in sleep here took a different, more assertive turn as she faces her watchers; the 1850s was a period of heightened interest in the phenomenon of sleep-walking.

40 *The Meuse at Freyr*
LILLE, Musée des Beaux-Arts. 1856? Signed lower right: G. Courbet. 58 × 82 cm.

Courbet is not thought to have made a long stay in Belgium until 1856, when he probably painted this view of cliffs near Dinant, overlooking the Meuse. No doubt a reminder of his rugged home environment of Ornans, this landscape ends abruptly in the huge cliffs on the opposite bank of the river; a superb example of Courbet's knife-painting, it shows the confidence with which he handled this difficult technique and the resultant force of the painted image. The steep perspective of the foreground, anchored by the trees at the right, moves upwards almost vertically to the cliffs, reinforcing the tactile surface of the painting and tending to flatten the picture space.

V *The Meeting* or *Bonjour Monsieur Courbet*
MONTPELLIER, Musée Fabre. Signed and dated lower left: 54 G. Courbet. 129 × 149 cm.

This painting, which commemorates Courbet's arrival outside Montpellier in May 1854 on his first visit to the home of Bruyas (Plate 31), was commissioned by the collector in 1854. It shows Courbet on the right, having apparently disembarked from the Paris diligence, which can be seen in the distance, before its arrival in Montpellier. On the left are Bruyas and his man-servant and dog, greeting the traveller on his arrival; the painting was also called at the time, by the critic Edmond About, 'Fortune bowing to genius'. The location has been suggested as Lattes, where the road to Sète crosses that leading to Saint-Jean-de-Védas, outside Montpellier. The composition itself derives from a popular print (fig. 5) on the theme of the Wandering Jew, which has been identified by Linda Nochlin in her doctoral thesis (1963), in which the Jew meets two bourgeois in a country setting. Courbet's treatment of his bohemian portrait of *The Apostle Jean Journet* the Fourierist prophet, (fig. 4), was similarly inspired by the Wandering Jew legend, Courbet's identification with it being that of the outsider. The landscape of *The Meeting* is flat and open, with a low horizon reminiscent of certain Dutch seventeenth-century landscape paintings; in Courbet's work it serves to enlarge and emphasize the figures which are thus silhouetted against the bright sky. As in the final version of *Young Ladies of the Village* (Plate 28), the landscape is disjointed; the foreground is tipped forward to provide a 'platform' for the figures, and its relation to the landscape beyond is intentionally uncomfortable. Foreground and background use different viewpoints, and the middle ground is non-existent, thus creating a sudden leap into the distance moderated only by the inclusion of the diligence on the right. But again this provides essential support for the main action of the painting, eliminating any distraction that might have competed with the supremacy and force of the figures which dominate the composition. Contemporary critics noted, when the painting was shown at the 1855 Universal Exhibition in Paris, the artist's egotism in his rather arrogant treatment of himself (he is the only figure to cast a shadow) and in the deferential respect of Bruyas and his servant.

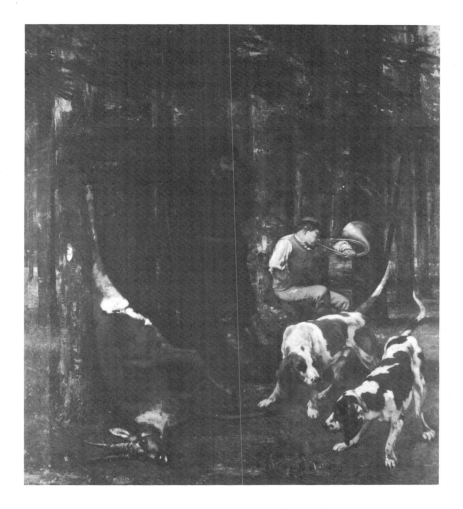

41 *The Quarry: A Deer-hunt in the Forests of the Grand Jura*
BOSTON, Museum of Fine Arts (Henry Lillie Pierce fund). 1857. Signed lower right: G. Courbet.
210 × 180 cm.

This was Courbet's first large-scale hunting scene and was greeted favourably at the Salon of 1857;
from this success onwards Courbet turned increasingly to wooded landscape scenes populated by
game which became extremely popular with the public and caused him to 'mass-produce' this type
of painting, usually on a rather smaller scale, to meet the demands of collectors. In consequence
the standard of work in this genre of paintings varies considerably, and few reach the high quality
of *The Quarry.* In the centre of this scene, leaning against a tree and surveying the action, is Courbet
himself, with an uncharacteristically up-turned moustache; he depicted himself much darker than
his surroundings, blending into the sombre tones of the trees. The two dogs apparently devour the
deer's entrails, while the red-waistcoated huntsman blows his horn. Champfleury, in his essay on
the artist, 'Courbet in 1860', felt this picture was a concession to the public and second-rate
because of its subject matter. The painting was enlarged after 1862 with the addition of a strip of
canvas at the top and left. This was done by the artist at the request of the dealer Luquet, who
owned it then and felt it lacked 'air'; originally Courbet's head was level with the top of the
picture.

VI *Seascape at Palavas*
MONTPELLIER, Musée Fabre. Signed lower right: G. Courbet; dated lower left: 54. 27 × 46 cm.

This painting, sometimes called *Courbet Saluting the Mediterranean*, is a celebration of Courbet's first
visit to that sea in 1854. He wrote at this time to Jules Vallès: 'The sea's voice is tremendous, but
not loud enough to drown the voice of Fame, crying my name to the entire world.' Whistler
painted a seascape *Harmony in Blue and Silver* (Boston, Isabella Stewart Gardner Museum) in
Trouville in 1865, with Courbet appearing in the foreground. The little figure of Courbet in
Seascape at Palavas appears to have 'bled' and probably indicates some reworking coming through
the surface layer of paint. Some cracking is visible in the heavily impasted light areas of the
painting, sky and foreground, revealing Courbet's habitual dark ground beneath; some semi-
circular crack lines in the top left corner may indicate that the stretcher keys were tapped in at
that joint, straining the paint surface. The artist was evidently using a combination of brush and
palette knife work; the textured marks of a brush are clearly visible in the foreground, while
amongst these, particularly in the application of the final highlights of the water's edge, the
flattened, uneven 'catching' of knife work is visible in the paint.

42 *Portrait of Louis Gueymard as Robert le Diable*
NEW YORK, Metropolitan Museum of Art (gift of Elizabeth Milbank Anderson). 1857. Signed lower left: G. Courbet. 148 × 106 cm.

The tenor Gueymard was one of the most famous interpreters of the title rôle in Meyerbeer's opera, in which he made his début at the Paris Opéra in 1848. Courbet depicted Gueymard in the cavern playing dice with two servants of the devil; Bertram, at once his father and his evil genius, is seen in the background on the right. The scene is set at the moment when Robert sings the aria 'Oui, l'or est une chimère'. The Metropolitan Museum catalogue notes also that in 1856 the picture was described as unfinished by Théophile Silvestre, who probably saw it in Courbet's studio. This superb character portrait points forward to Manet's similar conventions in his 1877 portraits of the Opéra baritone *Jean-Baptiste Faure as Hamlet* (Essen, Folkwang Museum; unfinished variant: Hamburg, Kunsthalle), although in the Courbet picture the action of the scene is depicted in the background to the main figure. Emphasis on this figure is achieved through the use of dark tones subduing everything but Gueymard, who is lit well, evenly from the front; a strange light contour is visible around the raised hand of Gueymard, and this may be an unresolved adjustment on the part of Courbet. Another perhaps intentionally unresolved area is the table, where the perspective is contradictory, leaving the dice, the box and the glove all on different planes.

43 *Portrait of Mathilde Cuoq, née Desportes*
NEW YORK, Metropolitan Museum of Art (bequest of Mrs. H. O. Havemeyer). 1857. Signed lower right: G. Courbet. 176 × 108 cm.

This elegant and fashionable full-length portrait is unusual in Courbet's *oeuvre* and probably indicates the wishes of the sitter and her husband rather than Courbet's own taste. Nevertheless, the rich fabrics gave the artist ample opportunity to exercise his talent in their treatment, and, although rather forced and uncomfortable in pose, the result is stunning. Yet again Courbet used the minimum devices to indicate depth in the painting, with only the table and foot-stool hinting at recession; the pictorial space is shallow, closed off abruptly at the right with the drape and elsewhere by the grey, indefinite background, both enclosing rather than releasing the figure. Highlighting draws attention to the most important elements of the painting, the flesh passages. The addition of a strip of canvas at the bottom of the painting, on which the artist's signature appears, was made by the artist although it seems to detract from the compact composition, giving unnecessary space to the foreground.

44 *Portrait of Madame de Brayer*, called *The Polish Exile*
NEW YORK,, Metropolitan Museum of Art (bequest of Mrs. H. O. Havemeyer). Signed and dated
lower right: G. Courbet 58. 91 × 72 cm.

This portrait, traditionally said to be of a Polish exile married to a Belgian, was painted by
Courbet on a trip to Brussels. An extraordinarily powerful painting, and much more typical of
Courbet than his treatment of Mathilde Cuoq (Plate 43), -it is in the tradition of noble portraits of
the Renaissance, with the restrained dignity and self-containment of the sitter. The use of light and
shade in this work is particularly emotive, as Courbet left the right side of her face in mysterious
shadow while from the illuminated side her dark limpid gaze holds the spectator; the light catches
also on the relaxed curves of her hands and forearms. Her face is coolly enigmatic. Although a
studio painting, this portrait was given an outdoor, balcony setting in which distance is cut off by
the masses of foliage, loosely painted not to distract the eye from the sitter; this produces a shallow
pictorial space and, with the strength of tonal contrasts in the figure, results in a very forceful
characterization. It is simultaneously one of Courbet's most sensitive portraits, and it is easy to see
why Degas admired it when he saw it in Brussels.

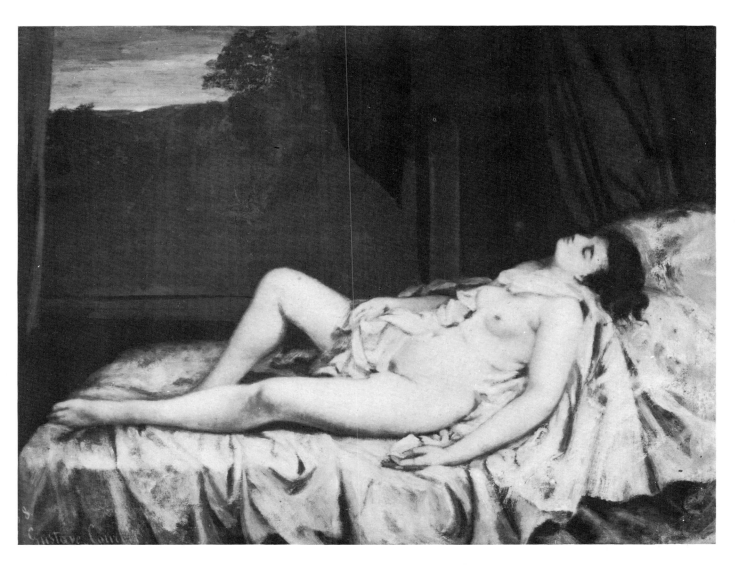

45 *Woman Resting*
Private collection. Signed and dated lower left: 58 Gustave Courbet. 51 × 64 cm.

This small-scale, intimate nude study is in the genre of 'boudoir paintings' and is distantly related to the tradition of Giorgione and Titian; this was a genre for which Courbet seems to have found ready buyers, which may have encouraged him to produce his many others. Courbet again chose a pose which depicts his model lost in sleep and in a pose not unsuitable for its intended function, inviting the sexual fantasies of the, by implication, male spectator. It is a strange composition, with foreground, background through the window and no apparent middle ground to link them; the theatrical drapery almost suggests an erotic *tableau vivant*, the precursor of the strip-tease.

46 *The German Hunter*
LONS-LE-SAUNIER, Musée des Beaux-Arts. Signed and dated lower left: 59 Gustave Courbet.
118 × 174 cm.

This canvas was painted during Courbet's stay in Germany in 1858–59 and probably shows one of his hunting companions of that time; he has not been identified to date. It is an unusual composition, with all the action immediately in the foreground, the figure of the hunter balanced by the tree leaning over the brook at the same angle on the right and by the straining neck of the dying stag. A powerfully rendered painting, it shows Courbet's love of the hunt and outdoor life and is one of the most successful of its kind in the artist's *oeuvre*.

47 *Stag Taking to the Water: Stag at Bay*
MARSEILLES, Musée des Beaux-Arts. Signed and dated lower right: Gustave Courbet 61.
220 × 275 cm.

This picture and *Stags Fighting* (Paris, Musée du Louvre), of the same period, are two of Courbet's
most important animal paintings, and their scale brings them close to his great Realist figure
canvases of the 1850s. Courbet wrote concerning the scene of this painting: 'it takes six hours to
run down a stag and the scene is therefore in the evening: the sun's last rays are nearly horizontal,
and the smallest objects cast very long shadows. The way the light falls on the stag emphasizes the
speed with which it is running and makes the picture more impressive. It is entirely in shadow and
yet fully modelled, the ray of light is sufficient to indicate its form; it seems to be speeding away
like an arrow or dream. The expression of its head ought to please the English: it recalls the feeling
of Landseer's animals.' Linda Nochlin (in *Art Bulletin*, 1967) has pointed out the similarity
mentioned here by Courbet to the animals of Landseer, and she reproduces a print after a stag by
Landseer which was reproduced in the *Magasin Pittoresque* in 1851, which Courbet probably knew.
It is also possible that Courbet's love of such scenes as this may be autobiographical; he had
already identified with the bohemian image and with the legend of the Wandering Jew, another
social outcast, thus in his depictions of dying stags persecuted by hunters and eventually meeting
an unavoidable death, we may have further proof of Courbet's feelings of isolation from society.
Stag in the River (Plate 54) shows Courbet's repetitive use of a motif, deploying the same pose of the
stag as in the Marseilles painting, but in a different context and scale.

48 *Portrait of Madame Robin*, called *The Grandmother*
MINNEAPOLIS, Minneapolis Institute of Arts (William Hood Dunwoody fund). Signed and dated lower left: 62 G. Courbet. 92 × 73 cm.

In this gentle and touching portrait, with the figure of Madame Robin taking up a large area of the picture surface, Courbet gave his sitter an imposing presence by placing her head so high up the canvas. A neutral background and simple triangular composition endow the figure with weight and emphasis, while subtle details, such as the soft fabrics and delicate laces, evoke the age and vulnerability of the woman. This portrait was painted in repayment of a loan dating from Courbet's student days.

VII *The Winnowers* or *Women Sifting Grain*
NANTES, Musée des Beaux-Arts. Signed and dated lower left: 55 G. Courbet. 131 × 167 cm.

Courbet himself called this a strange picture, in the same series as *Young Ladies of the Village* (Plate 28), showing the activities of women in his home area of Ornans. The present picture, which was subtitled *Farmers' Daughters from the Doubs* when it was shown in Besançon in 1860, is one of his series specifically on the theme of work; it is a reminder of Courbet's statement in his 1855 manifesto: 'To know in order to be able to create, that was my idea. To be in a position to translate the customs, the ideas, the appearance of my epoch according to my own estimation; to be not only a painter but a man as well; in short, to create a living art – this is my goal.' His concern in particular was with that which he knew and understood most fully, the rural life of Ornans. This is a dramatic composition with the central, graceful figure posed by his sister Zoé turned away from the spectator, a not unusual device in Courbet's paintings, for instance *After Dinner* (Plate 17) and *The Bathers* (Plate IV); Toussaint proposes a new identification for the other two models here, the seated girl as Juliette Courbet, the young boy as Désiré Binet, the artist's unacknowledged son (b. 1847) by his mistress Virginie Binet. This canvas was bought by the Musée des Beaux-Arts, Nantes in 1861 for 3000 francs.

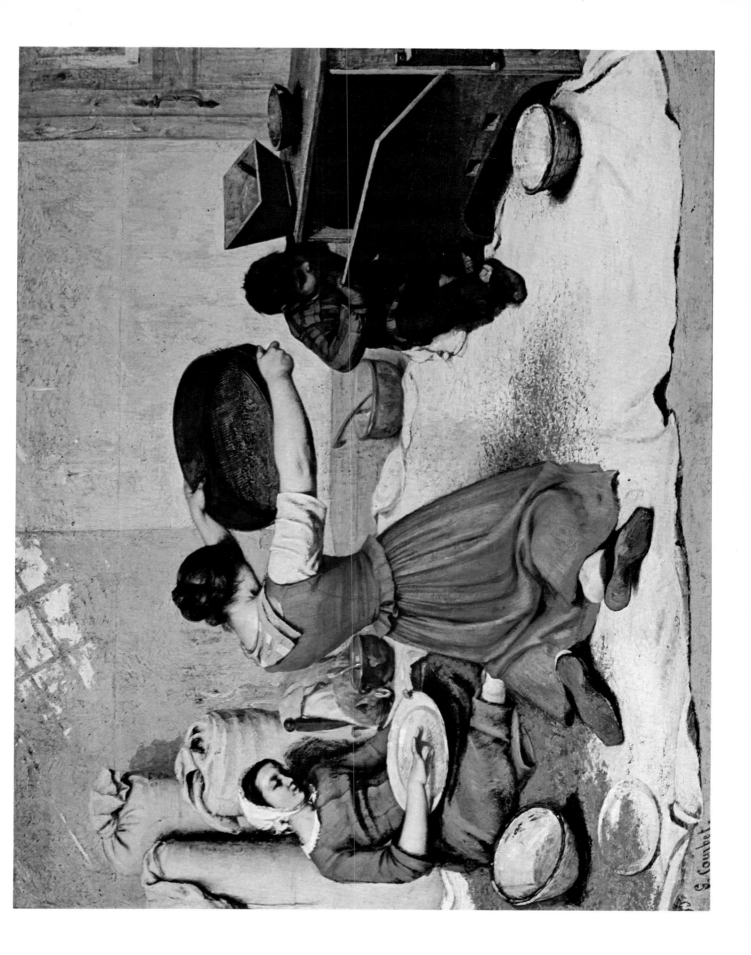

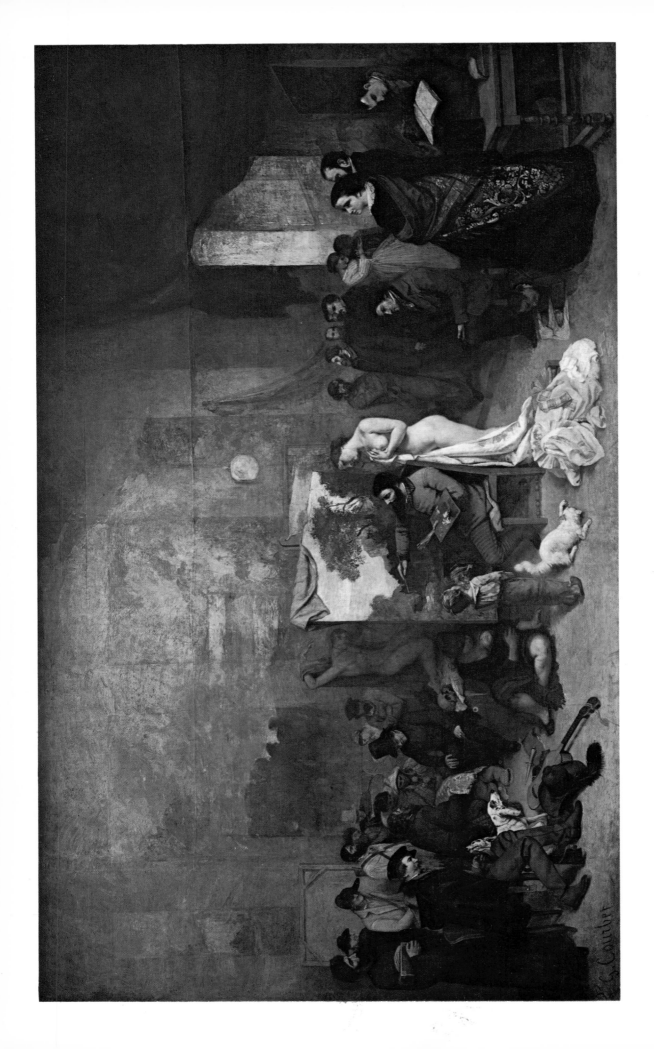

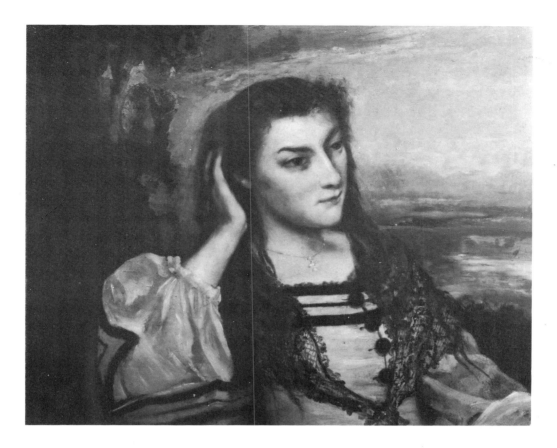

49 *Reverie – Portrait of Gabrielle Borreau*
PARIS, private collection. Signed and dated lower left: G. Courbet 62. 63 × 77 cm.

Bonniot, in *Courbet* 1969, proves that this portrait is of the daughter of Madame Laure Borreau, and not the mother herself, Courbet's mistress, as had previously been thought. Courbet's fourteen-year-old sitter is placed against a landscape, beside the sea, with a sombre, Romantic sunset behind her; her tresses are loose and flowing in the manner often seen in Courbet's studies of women. The strange tilting of her eyes in the portrait, particularly her left eye, adds a bizarre note to this apparently tranquil scene. The rendering of all but the flesh passages is free and vigorous, with the purple clouds behind her head having been added, it would seem, at a late stage in the painting, as the colour was worked over the background foliage and in places over her hair too. The treatment of fabric texture appears less successful than in the superb *Young Ladies on the Banks of the Seine* (Plate IX).

VIII *The Artist's Studio: A Real Allegory Determining a Phase of Seven Years of my Artistic and Moral Life*
PARIS, Musée du Louvre. Signed and dated lower left: 55 G. Courbet. 361 × 598 cm.

This complex and fascinating painting has been the subject of numerous studies by art historians, most of which concentrate in particular on the development and iconography of the composition. Linda Nochlin (in *Avant-Garde Art*) puts forward a Fourierist interpretation of the painting, which is to some extent dependent upon the identification of the bourgeois couple at the far right as the Fourierist François Sabatier and his wife. However, this richly dressed, elegant woman was identified as another Madame Sabatier, La Présidente of Parisian *demi-monde* fame and Baudelaire's 'White Venus', by Joanna Richardson in *The Courtesans*. This identification has been affirmed by Toussaint (*Courbet*, 1977–78). The figures on the right, those who live on life, are from left to right, Courbet's friend the violinist Alphonse Promayet, who appeared in *After Dinner* (Plate 17), next the collector Alfred Bruyas in profile, and close together P.-J. Proudhon, Urbain Cuénot and Max Buchon. Seated in the foreground is Champfleury, the Realist writer and supporter of Courbet, and behind him a pair of symbolic lovers. Beyond the bourgeois couple is Baudelaire, taken from his portrait of the late 1840s (Plate 15); a portrait of Baudelaire's 'Black Venus', the mulatto Jeanne Duval, at the writer's side was painted over by Courbet at his special request but can now be dimly seen on the blank wall between Baudelaire and the bourgeois couple. A small boy is shown at their feet crouched and apparently drawing. The figures standing on the left, the outcasts, include the Jew at the extreme left, a figure who, in the form of the Wandering Jew (fig. 5), was behind two of Courbet's major works of the 1850s, the lost *Portrait of Jean Journet* of 1850 (fig. 4) and *The Meeting* (Plate V); next appear a curé, an old Republican, a huntsman with his gun slung on his back and a supposed peasant labourer. The crouched, central group on the left includes a clown, a professional strong man, a mower, a working-class couple and an undertaker's mute who are all being shown the wares of a rag-picker. Immediately behind the artist's easel appears a

50 Basket of Flowers

GLASGOW, Glasgow Art Gallery. Signed and dated lower left: 63 Gustave Courbet. 75 × 100 cm.

Courbet went in May 1862 to the Château of Rochement, near Saintes, the home of his friend Etienne Baudry, intending to visit for a few days, but he ended up staying for a year there, he also stayed for a further few weeks there in the summer of 1863. While he was at Rochement Courbet painted a large number of flower pieces, which may have been inspired by Baudry's interest in botany. This superb still-life of flowers, one of Courbet's greatest, is in the tradition of Dutch seventeenth-century flower pieces, which were often allegorical. Toussaint points out that Courbet's painting may also be allegorical, as it contains flowers from the four seasons and cannot therefore have been painted from life (*Courbet* 1977–78). The picture presents a close view of the flowers, completely filling this large canvas and treated in rich and fluid paint, using a variety of techniques including a 'stubbled' effect to convey the texture of the lilac on the left. The weave of the basket was laid on forcefully with deft individual brushstrokes; the basket is placed on a table whose edge falls carefully parallel to the picture plane and whose recession is more or less lost in the deepening chiaroscuro of the vague sombre background.

lifesize lay-figure, traditional studio furniture for large scale figure paintings, which is noticeably shunned by Courbet here working on a landscape with the lay-figure obscured from his view; this may be a reflection of his anti-academic sentiments. At the figure's feet lies a skull on a newspaper and below that an Irish woman, a symbol of poverty so close in time to the Irish potato famines, suckling a baby. The most prominent figure to the left, apparently another huntsman, is seated and wearing high leather boots, with two gun dogs close at hand. A still-life at his feet completes the group. The years of Courbet's life summed up in this allegory were 1848–54. *The Artist's Studio* was first exhibited at Courbet's one-man show of 1855, having been rejected, along with the *Funeral* (Plate II), by the 1855 Universal Exhibition jury. It is significant to note that almost all of Courbet's large-scale compositions were painted specifically for major public exhibitions like the Salon, or in the case of the present painting, the Paris Universal Exhibition of 1855, and had no projected permanent site; they were thus, unlike traditional history paintings, essentially an individual's *tours de force*.

51 *The Gour de Conches*
BESANÇON, Musée des Beaux-Arts. Signed and dated lower left: Gustave Courbet 1864. 70 × 60 cm.

Courbet painted many beauty-spots. This picture of one near Salins was executed as part of a
commission for a rich industrialist Alfred Bouvet, whom Courbet met during his stay in Salins in
1864 with Max Buchon. Toussaint recognizes in this work a caricature of the landscape, not
dissimilar to Courbet's *Fantastic Landscape* (Plate 53), though far less obvious (*Courbet* 1977–78). In
this dramatic landscape the spectator is again faced with a wall of rock, as in *The Meuse at Freyr*
(Plate 40) and the *Fantastic Landscape*, which cuts off any distant vanishing point or horizon, leaving
only a small patch of sky high in the composition. This results in a very enclosed and
claustrophobic pictorial space, with no visual relief or freedom.

52 *The Ferme des Pussets*
JAPAN, Collect of Mr. Sugihara. Signed and dated lower left: 1864 Gustave Courbet. 54 × 65 cm.

This painting was executed by Courbet on a visit to his friends the Joliclers in Pontarlier in 1864. It seems a rather unusual, almost picturesque view, rare in his work by this date, when his landscapes were nearly always wild and uncivilized, with little foreground and a cramped, closed-in pictorial space, trees often excluding the sky completely. In some ways this is a traditional landscape composition, with a tree at the left framing the view and leading the eye into the picture, down the valley to a hamlet and up again to the farm of the painting's title.

53 *Fantastic Landscape with Anthropomorphic Rocks*
PARIS, private collection. After 1864. Signed lower left: G. Courbet. 93 × 87 cm.

This painting was published for the first time in *Courbet* 1977–78 and illustrates an underestimated aspect of Courbet as an artist, which found its outlet in the imaginative 'humanizing' of rocks, transforming natural phenomena into human forms. Toussaint (*Courbet* 1977–78) sees a similar interest in Courbet's rendering of the landscape in *The Gour de Conches* (Plate 51); the fashion for this type of painting had been revived at the beginning of the nineteenth century and was frequent in the popular imagery of the Romantic period. This painting surely serves to underline the importance of a symbolic interpretation or understanding of Courbet's landscapes of this period.

54 *Stag in the River*
PARIS, private collection. 1864? Signed lower right: G. Courbet. 73 × 92 cm.

Although the stag here is on a much smaller scale relative to the overall landscape, it is basically the same animal as in *Stag Taking to the Water* (Plate 47) and is one of the more inspired examples of Courbet's re-use of a motif, which in many cases were lifeless and unsatisfactory.

55 *The Grotto of the Loue*
WASHINGTON, National Gallery of Art (gift of Charles L. Lindemann). c. 1865. Signed lower left:
Gustave Courbet. 98·4 × 130·4 cm.

This curiosity of nature in the Franche-Comté was painted many times by Courbet, but the
Washington picture is among the most finished and interesting of them all. The minute figure of
the man dwarfed by the colossal cave mouth is reminiscent of the similarly scaled figure of the
artist in *Seascape at Palavas* (Plate VI), in which Courbet's left arm is raised in salute; in *The Grotto
of the Loue*, the figure is less elegantly clothed and raises his right arm, apparently ferrying himself
across the water. The sexual connotations of this extraordinary image are hard to avoid; the gaping
grotto, flowing with the waters of the Loue, presents itself throat- or vagina-like, while the erect but
diminutive figure of the man stands silhouetted, with trousers rolled up, at its edge.

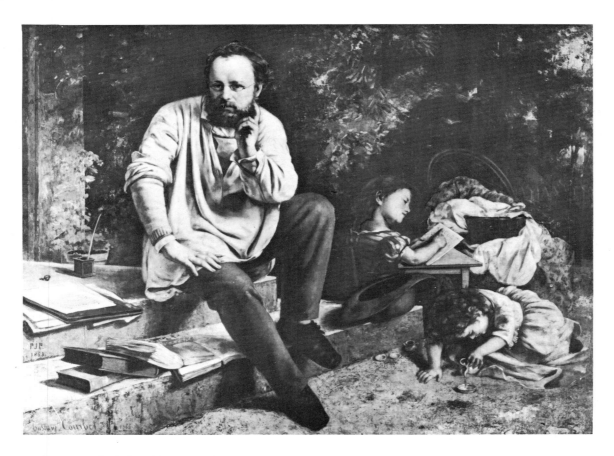

56 *Protrait of P.-J. Proudhon in 1853*
PARIS, Musée du Petit Palais. 1865. Signed and dated lower left: Gustave Courbet 1865; annotated
left on the step: P.J.P. 1853. 147 × 198 cm.

Courbet himself called this portrait of his friend Proudhon a 'historical portrait'; for many years
the artist had planned a portrait but Proudhon had refused to sit for him. After the socialist
philosopher's death in January 1865, Courbet at last began a portrait, choosing the year 1853,
perhaps as the most difficult of the writer's career. Proudhon, originally from Besançon, in
Courbet's own home area, is shown seated on the steps outside his Paris home in the rue d'Enfer,
with his, at that date, two children; his wife was originally seated where there is now only a chair,
but Courbet painted her out after the canvas appeared in the Salon of 1865. The portrait was
painted in Ornans, based on a photograph taken by Reutlinger at Courbet's request in 1863,
another of Proudhon on his deathbed by Carjat and a photograph of a portrait of Proudhon by
the Belgian artist Amédée Bourson, painted when the writer was in exile in Brussels and shown at
the Salon of 1861. Courbet's treatment is an unusual portrait, showing the writer dominating the
left side of the composition, with his first two daughters playing behind him; a blank wall behind
the writer's back was changed by the artist to the present background of foliage following
unfavourable comments by the critics in 1865.

IX *Young Ladies on the Banks of the Seine in Summer*
PARIS, Musée du Petit Palais. 1856–57. Signed lower left: G. Courbet. 174 × 200 cm.

This painting can be seen as a forerunner of works by Manet from the 1860s such as *The Picnic*
(Paris, Musée du Jeu de Paume), which was shown at the Salon of 1863 and which treats a similar
riverside leisure scene, but with the added scandal-provoker of a nude woman in the foreground
with two dressed men. Here the male presence is only implicit, if more uncomfortably, in the
foreground girl's *déshabillé* and her sensuous half-lidded gaze directed at the spectator, the implied
male presence. Courbet's title for this painting was significantly given by Proudhon as 'Two young
women of fashion under the Second Empire', a theme which would have fitted into Baudelaire's
definition of subjects for a 'Painter of Modern Life'. Proudhon felt Courbet's purpose in the picture
was to expose the easy morals of kept women, but considering Courbet's evident delight in
depicting highly sensual images of women, it seems extremely unlikely that the moral judgement
was delivered by anybody but the austere Proudhon. The verisimilitude of Courbet's rendering of
fabric and texture in this painting comes close to that of Ingres in works such as the *Portrait of
Madame Rivière* of 1805 (Paris, Musée du Louvre); Courbet depicted a creamy silk embroidered
shawl, similar to that of Madame Rivière, flung over the foreground girl's petticoats, and he also
exploited the qualities of fine transparent gauzes and lace in the girl's exposed underwear, fabrics
which were often used by Ingres. This painting was begun in Ornans in 1856 and completed in
Paris the following year; it was shown at the Salon of 1857.

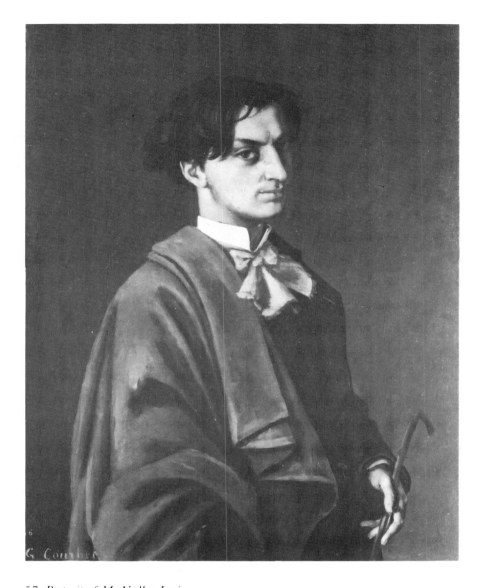

57 *Portrait of M. Nodler Junior*
SPRINGFIELD, Museum of Fine Arts (James Philip Gray collection). 1865. Signed and dated lower left: 66 G. Courbet. 93 × 73 cm.

Courbet spent the summer of 1865 in the fashionable seaside resort of Trouville on the Normandy coast, where he was in great demand as a portraitist among the society crowds. A letter of 1865 confirms this and not the inscribed '[18]66' as the year of execution of this painting, not surprising in view of the artist's casual dating attitude towards his works. This is an unusually sombre, Romantic portrait, reminiscent in the pose of the head and its brooding, tilted eyes to *Reverie, Portrait of Gabrielle Borreau* of 1862 (Plate 49); both have a similar introspective intensity, although that of Nodler has a darker, more sensuous containment.

X *The Trellis* or *Girl Arranging Flowers*
TOLEDO (Ohio), Toledo Museum of Art (gift of Edward Drummond Libbey). 1863. Signed lower left: G. Courbet. 110 × 135 cm.

This delightful composition was Courbet's most important painting, again inspired by flowers, resulting from his stay in Saintes. Toussaint suggests that Courbet's debt to the Old Masters in this work is confirmed by the artist's knowledge of the theme's underlying significance, the glorification of youth and love, symbolized by the young girl shown with the flowers of spring, summer and autumn, which represent the three stages of her amorous life (*Courbet* 1977–78). This richly coloured, graceful painting shows a girl with arms upraised tending the flowers, which dominate the left half of the canvas. Again Courbet used a very shallow pictorial space, closed off by the trellis and the girl, leaving only a fraction of ill-defined background behind her back. The artist evidently had some difficulty in 'releasing' the figure from the background, as seen in the heavy working and dark contour around her face and the thickness of paint following the contour of her back; this results in an awkward 'cut-out' quality to the figure. The floral fabric of her dress carries on the motif of the flowers, enlivening the whole canvas surface with brilliant touches of warm colour.

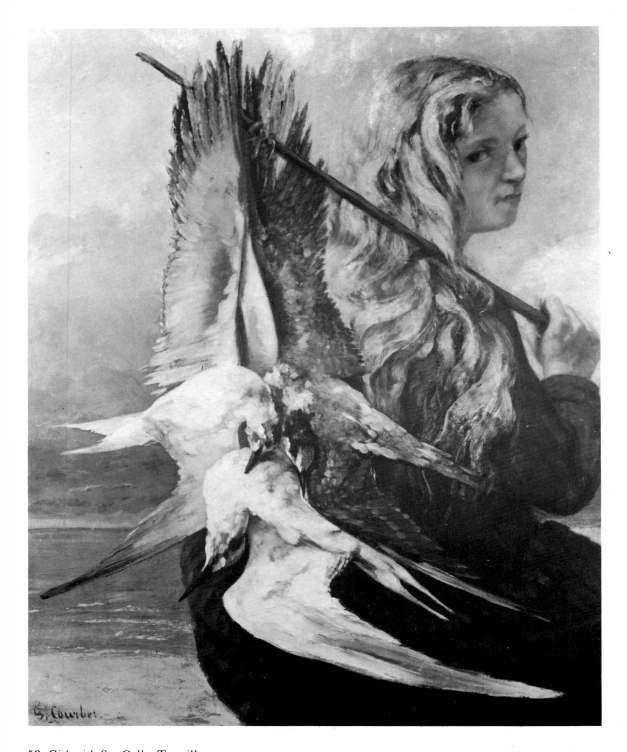

58 *Girl with Sea Gulls, Trouville*
NEW YORK, collection of Mr. and Mrs. Jamess. Deely. 1865. Signed lower left: G. Courbet.
81 × 65 cm.

This extraordinary composition is again evidence of Courbet's love of the sensuous possibilities of female hair, combined here with birds' plumage, a feature which reappears in his *Woman with a Parrot* (Plate 63) and the lost version of *The Awakening* of 1864, reproduced in Fernier's *Gustave Courbet* on p. 55. The subject matter of *Girl with Sea Gulls* is brought dramatically close to the picture plane, forcing a direct confrontation with the spectator and producing a most unusual painting. The seagulls are in fact terns.

59 *Low Tide*, called *The Immensity*
BRISTOL, City Art Gallery. 1865? Signed lower right: G. Courbet. 61 × 82 cm.

Courbet painted many such empty, atmospheric seascapes, some even from memory (Plate 77); he
frequently chose an unexpected format for such works, a squarish canvas, in a genre which was
more usually undertaken on a long, narrow canvas to emphasize the panoramic qualities of the
motif. The disposition of his subject on the canvas and the lack of 'accessories' used were also
unusual; many contemporaries, such as Boudin (1824–1898), added figures or buildings to the
'wings' of a seascape and thus helped articulate the sense of vast space suggested by the sea and
sky. Courbet occasionally used such devices (Plate 77 and Plate VI), but as in the Bristol painting,
he more often left them uncluttered. His choice of viewpoint, the disposition of his subject on the
canvas, is also striking; he placed land, sea and sky in horizontal bands parallel to the picture
plane, creating something of an ambiguity between the flat, often visibly knife-worked and strongly
physical paint surface and the atmospheric sense of three-dimensional space evoked by the subject.
Such ambiguities later played a central part in the work of the Impressionist Claude Monet
(1840–1926). In these seascapes Courbet may have been attracted by the quality of emotional
isolation and majesty in the subject; they also provided him with an excellent vehicle for masterly
colour and tonal modulation in the depiction of varying weather conditions and times of the day.
In this he may have been influenced by Boudin, whom he had met in 1859, who was particularly
concerned with such atmospheric changes and who was famed for his studies of the sky. Were it
not for Courbet's *Seascape at Palavas* (Plate VI) of 1854, one might also speculate on the influence
here of Whistler (1834–1903) whom he met at Trouville during the summer of 1865; as it is, the
American artist may have encouraged Courbet in his studies of the sea.

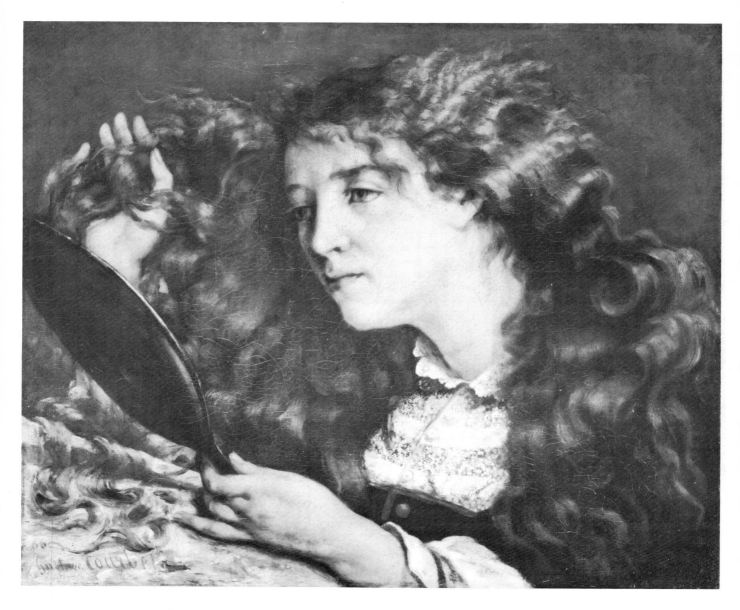

60 *Portrait of Jo, the Beautiful Irish Girl*
NEW YORK, Metropolitan Museum of Art (bequest of Mrs. H. O. Havemeyer). 1865? Signed and dated lower left: 66 Gustave Courbet. 56 × 66 cm.

Joanna Heffernan was the beautiful Irish mistress of Whistler, and she visited Trouville with him in 1865. This highly sensual portrait of Joanna, who also appears in *Women Asleep* (Plate XI) was apparently based upon a single sitting and shows her gazing intently in a mirror, a clothed version of the traditional 'vanity' theme. Her long flowing red hair and the exposed vulnerability of her neck touched by wisps of it are the major ingredients providing the powerful sexual undercurrent in this portrait. The sitter was brought up close to the picture plane, with her head, hair, hands and mirror completely filling the picture surface, creating the tightly packed, dense composition so typical of Courbet's most forceful paintings. The artist adopted a variety of brushwork to exploit most fully the varying textures before him and to emphasize the importance of the tactile sensation, bringing out the sensuality of his sitter. Courbet executed four variants of this painting. The New York version and that in the Nationalmuseum, Stockholm, were probably painted before the others; some authorities consider the Stockholm version the original, but both are equal in quality, though varying in small details.

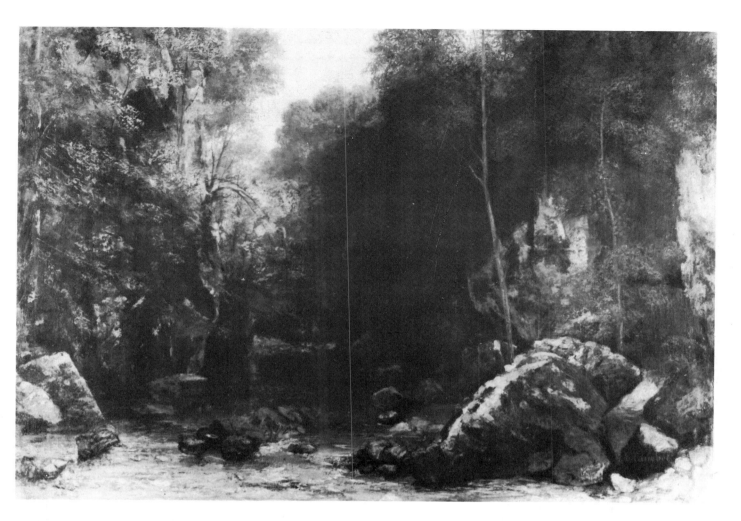

61 *The Shaded Stream* or *Les Puits Noir*
PARIS, Musée du Louvre. Signed and dated lower right: 65 G. Courbet 94 × 135 cm.

This is one of Courbet's many views of a beauty spot near Ornans, where the river Brême forces its way through a narrow gap between steep rocks covered in luxuriant vegetation. Toussaint points out that Courbet frequently placed his easel at the entrance to this almost impenetrable gorge, depicting the scene at different times of day and under different lighting conditions; the scene here is at twilight. Many of the variants are less successful than this painting and were often executed in the studio to satisfy the demand of collectors. The motif here, with its densely crowded vegetation, seems, like many others, to have been chosen by Courbet for the rich paint surface it would necessitate in translation on to canvas; widely varied knife-work and brushstrokes build up to an intensely physical and material painting, closed-in and compact in its reflection of the original spot.

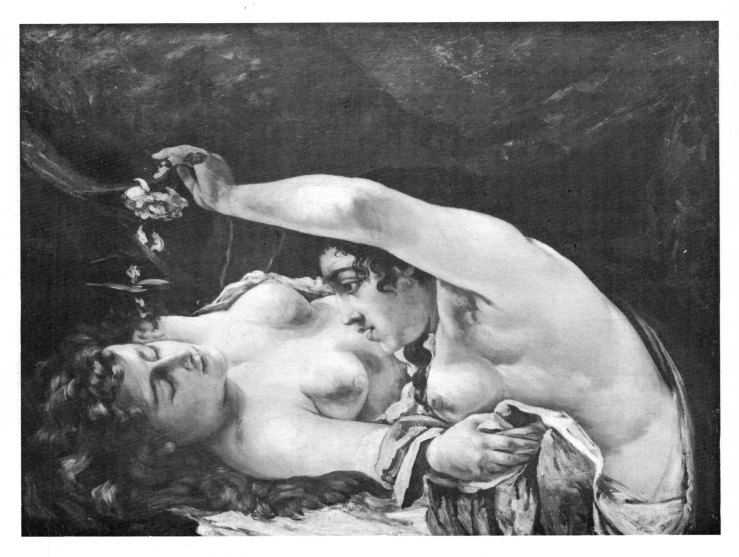

62 *The Awakening* or *Venus and Psyche*
BERN, Kunstmuseum. Signed and dated lower left: 66 G. Courbet. 77 × 100 cm.

This is a smaller version of the picture of the same name which Courbet submitted to the Salon of 1864 but which was refused on grounds of indecency. The larger, original picture was in the Gerstenberg collection, Berlin, now thought to be destroyed. The Bern painting is a modified version of the earlier picture and shows Courbet's increasing interest in themes of overt sexuality, reflecting the social climate of this decadent period. The theme of lesbianism was one which attracted many distinguished writers and artists during the nineteenth century, and it appears several times in Courbet's *oeuvre*, in, for example, *Women Asleep* (Plate XI). The two female figures are said to have been life-size and full-length in the original composition, while in the present picture they are half-length, but perhaps of more concentrated emotional presence. The composition is again packed with large, close-up figures, forcing the gaze of the spectator to come to terms with the passionate sexuality of the image. The full, taut flesh of the women accentuates their earthy sensuality, while the focal image, the face of the right-hand woman in profile, with her intense regard, her half-open mouth and the falling, dark curls of her hair, is aptly framed by three full breasts and her own fleshy arm.

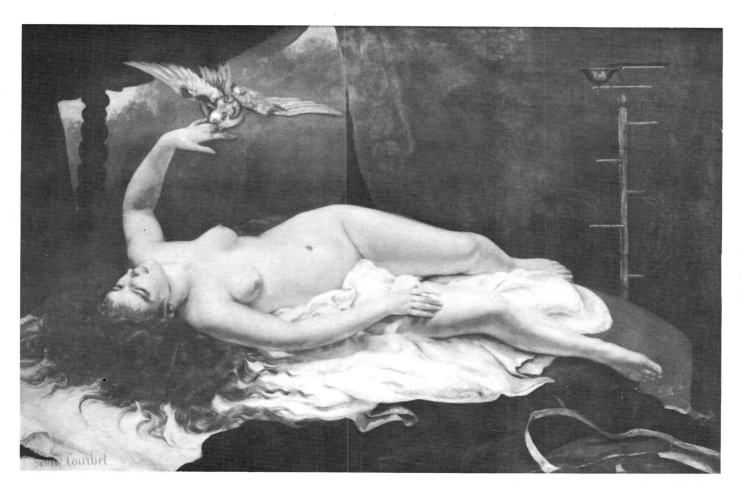

63 *Woman with a Parrot*
NEW YORK, Metropolitan Museum of Art (bequest of Mrs. H. O. Havemeyer). Signed and dated lower left: 66 Gustave Courbet. 129 × 195 cm.

The pose of this figure was based on the reclining figure in the possibly destroyed, original version of *The Awakening* (Plate 62) from 1864, illustrated in Fernier's *Gustave Courbet* on p. 55. In the *Woman with a Parrot*, however, the woman is awake and active, her left hand held above her head playing with her parrot; this change from the pose in the original *The Awakening*, in which the woman's arms were down beside her body, allows a sensual profile of the left breast to be revealed against the dark background. This painting and *Covert of Roe-deer* (Plate 64) were great successes at the Salon of 1866 and assured Courbet's growing popularity; they were, according to a letter to Bruyas in January 1866, both painted after that date in the remaining one and a half months before the opening of the Salon. Courbet may have used a photograph, reproduced in Scharf's *Art and Photography* as plate 86, as the basis for this composition.

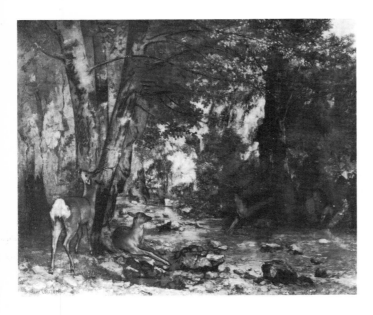

64 *Covert of Roe-deer by the Stream of Plaisirs-Fontaine, Doubs*
PARIS, Musée du Louvre. Signed and dated lower left: 66 Gustave Courbet. 174 × 209 cm.

This landscape was painted in Ornans, with the deer added later in Paris. Courbet wrote, in a letter to his friend Cuénot, describing the picture: 'It is a stream shut in by rocks and big trees: everything is light in colour. This winter I hired some deer and made it into a covert: there's a little doe in the middle, like a lady receiving company in her drawing-room. Her mate stands beside her, it is all quite delightful and they are finished like diamonds.' This letter also noted that the painting was worked over an earlier picture, begun for the Salon of 1854, *The Fountain of Hippocrene*, of which nothing can be discovered by x-ray and which apparently had been torn accidentally by Courbet's sister Juliette; the mend is still visible. *Covert of Roe-deer* is one of Courbet's most successful paintings of this genre, which he copied in varied compositions to meet the demands of collectors; powerful knife-painting in the landscape is complemented by the delicate brushwork in the treatment of the animals. Again Courbet chose, as he himself pointed out, a closed-in motif which he translated into a rich, dense paint surface.

XI *Women Asleep*
PARIS, Musée du Petit Palais. Signed and dated lower right: G. Courbet 66. 135 × 200 cm.

This painting was executed by Courbet for Khalil Bey, who was at one time the Turkish ambassador to St. Petersburg, but who preferred the life of indolent luxury in Paris, where he had a salon on the rue Taitbout at the corner of boulevard des Italiens. He was a connoisseur, and, before his expensive high living ruined him, Khalil Bey made an important collection of contemporary paintings. In addition to works acquired from Courbet, including *Women Asleep*, he owned Ingres's *Turkish Bath* of 1863 (Paris, Musée du Louvre), and his private collection was evidently intended to stimulate in rather specific ways, reflecting his Parisian life-style. The red-headed model in *Women Asleep* was Joanna Heffernan, Whistler's mistress and model, while the dark-haired woman was also used by Courbet in *The Awakening* (Plate 62) and its lost original. The composition used by Courbet enabled him to exploit his subject to the full; a viewpoint above the bed was chosen, looking down on the two women, whose positions were also arranged to provide maximum visual delight by exposing from every angle the key areas of sexual stimulation in the women's bodies. In particular the central view from behind, a popular one in the history of sexual images of women, was here given pride of position through the anatomical distortion of the dark-haired woman. The artist used other distortions to emphasize his main subject; the angle of the bed is noticeably at odds with the two side tables, which are both seen from a lower angle of vision. The rich colour and detail of the still-lifes and drapery enhance the luxuriance of the painting, while the broken string of pearls tells of abandoned passions and may also symbolize the loss of innocence. This painting has also been called *Paresse et Luxure (Idleness and Lust)* and *The Friends*, which has a more meaningful implication in the original French as *Les Amies*. Another, even more extraordinary, work executed by Courbet for Khalil Bey and called *The Origins of the World* was intended for a secret cabinet hidden like a religious triptych behind an innocent-looking landscape, only for the delectation of intimate friends. The work, thought lost since World War II, is reproduced in Peter Webb's *The Erotic Arts* (London, 1975) as plate 121 and was described by Maxime du Camp: 'a naked woman, viewed from the front, extraordinarily affected and convulsed, remarkably painted, produced "with love", as the Italians say, and the last word in realism. But, by some inconceivable oversight, the craftsman who had copied his model after nature, neglected to represent the feet, the legs, the thighs, the stomach, the hips, the breasts, the hands, the arms, the shoulders, the neck and the head...' The view point of the artist was from between the knees of his spread-eagled, prone model, and the function of this lost image leaves nothing to the imagination.

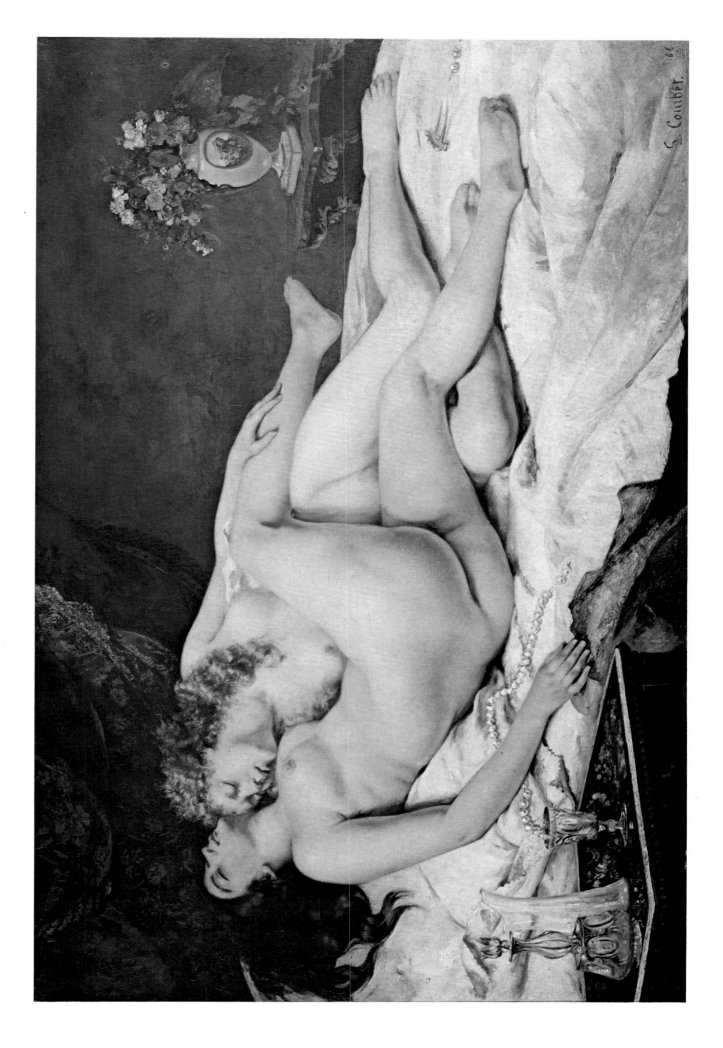

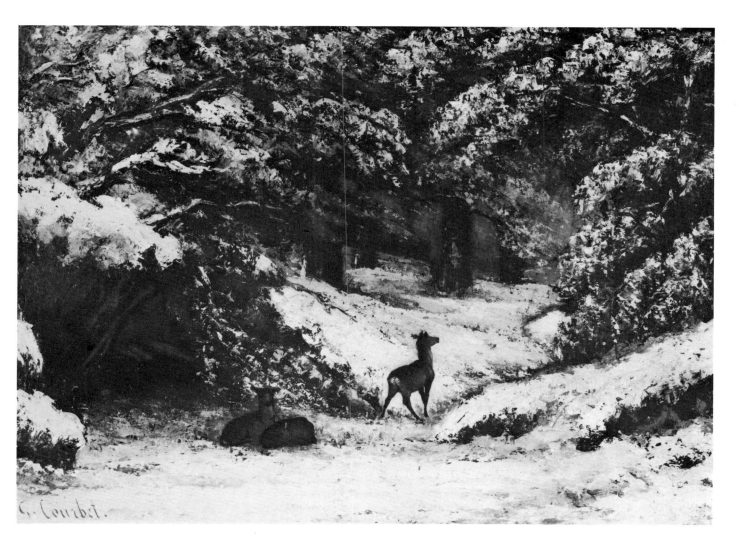

65 *Roe-bucks in Shelter in the Winter*
LYONS, Musée des Beaux-Arts. c. 1866. Signed lower left: G. Courbet. 54 × 72·5 cm.

Snowy landscapes were among the favourites of collectors of Courbet's hunting genre paintings; they were based on the scenery in his native Franche-Comté, and the people and animals were usually added afterwards. This painting shows yet another of Courbet's cramped and sky-less motifs, in which the sensation of the forest and laden winter trees is oppressively evoked.

XII *The Cliffs at Etretat (La Roche Percée)*
BIRMINGHAM, University of Birmingham, Barber Institute of Fine Arts. 1869? Signed lower left: G. Courbet. 76·2 × 123·1 cm.

Courbet stayed in Etretat on the Normandy coast in the summer of 1869; like other artists before him, such as Delacroix and Jongkind, Courbet was inspired to paint a series of views of the Etretat cliff formations, including this magnificent picture built up in varied touches of knife-painting over a dark lay-in. The boat was added last, with a brush, when the paint beneath was already dry; the paint ridges of the water show through (Plate 73). Its positioning serves as a balance for the heavy line of dark cliffs and as a diversion to the eye as it descends the sweep of the bay, stopping it short of the edge of the canvas and bringing the gaze back into the composition. The boat also helps give a sense of scale to the painting.

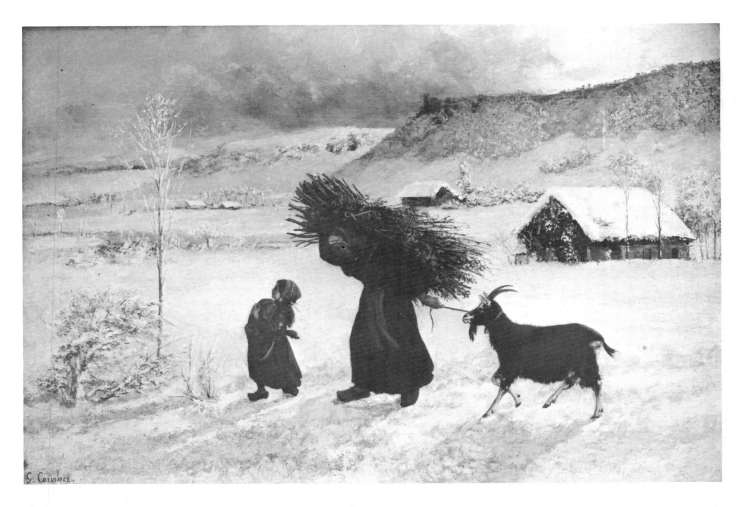

66 *Village Poverty, Ornans (La Pauvresse de Village)*
OTTAWA, private collection. 1867. Signed and dated lower left: 66 G. Courbet. 86 × 126.

Mack states that although dated 1866, this work was in fact executed the following spring; it is a quite different 'social' painting to those of Courbet's earlier period, during the 1850s. *Village Poverty* has not their impact, partly because the figures are on such a small scale in relation to the overall format, making it more of a peasant genre scene. The woman carrying the faggot is a reminder or perhaps even an evocation of the type made famous by Millet in, for example, *The Faggot Gatherers* of 1850–51 (Palm Beach, Art Museum of the Palm Beaches, Inc.).

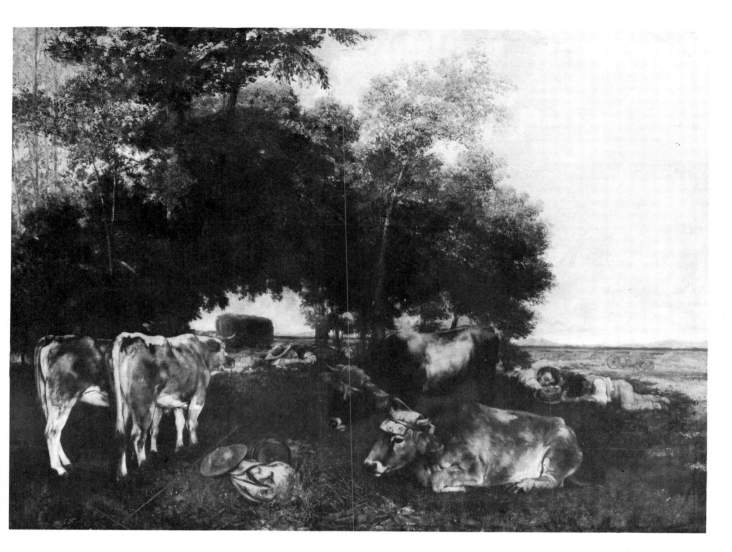

67 *Siesta at Haymaking Time, Mountains of the Doubs*
PARIS, Musée du Petit Palais. 1867. Signed and dated lower right: G. Courbet 68. 212 × 273 cm.

This painting was executed while Courbet was visiting his friends the Ordinaires in the summer of 1867; the doctor's two sons appear to the right of the composition. This scene harks back to the *Peasants of Flagey* (Plate 37) of 1850–55, in which the Dutch seventeenth-century tradition of rustic genre, with peasants and livestock, was evoked. In the *Siesta* the livestock dominate the scene, while the resting figures are of purely anecdotal interest, provoking none of the unease of the earlier, more powerful composition. Here Courbet allowed the 'rural idyll' to replace the previous rural unrest. The figure of a woman, which was more dominantly positioned in the immediate foreground, was replaced by Courbet, sometime after the Salon of 1869, by the present pile of clothes and a barrel; her prominent place may have disturbed the peace of the scene in Courbet's estimation. The central landscape device of shrouding trees through which a distant sunny vista opens out seems a direct quote from Barbizon landscape painting, in particular similar views by Théodore Rousseau.

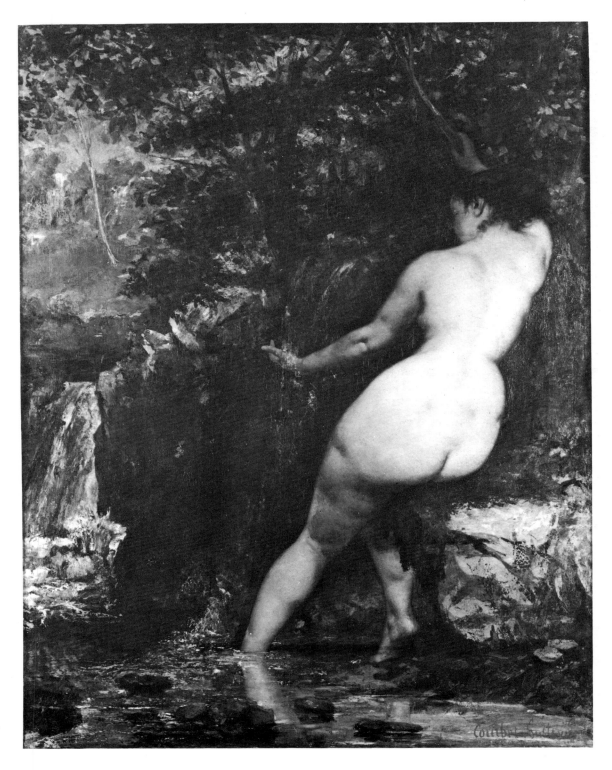

68 *Woman by a Spring* or *'La Source'*
PARIS, Musée du Louvre. Signed and dated lower right: 68 Gustave Courbet. 128 × 97 cm.

An x-ray has shown that a second female figure was painted out by the artist from a position at the centre of the picture. This extraordinary canvas, in which the painting of the landscape is so vigorous as to take on a life of its own, the nude sitting awkwardly within it, was given its title *'La Source'* by Courbet himself, thus placing it within the European tradition of symbolic women-water-source subjects. This seems a far less exciting painting than Courbet's earlier *Bathers* (Plate IV).

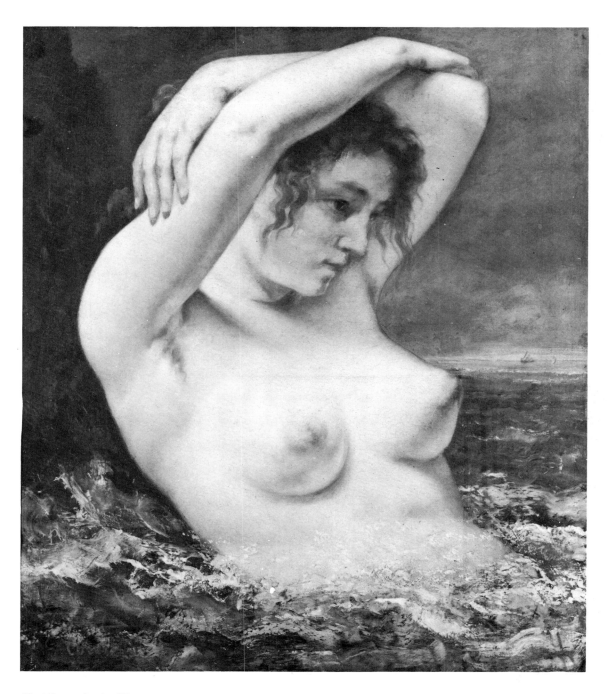

69 *Woman in the Waves*
NEW YORK, Metropolitan Museum of Art (bequest of Mrs. H. O. Havemeyer). Signed and dated lower left: 68 G. Courbet. 65 × 54 cm.

This delicious painting, with its almost humorous touch of the tiny ships on the horizon, shows Courbet testing his skills on a Realist 'Venus rising from the waves'; Courbet's use of the knife for painting the water, by contrast to the delicate handling of brushwork in the flesh, can be seen clearly in this work. As with the majority of the artist's nudes, the model's eyes are averted to avoid confrontation with the spectator; her soft, large breasts, with nipples surprisingly relaxed considering her situation, are shown by the artist to their fullest sensual potential. It is interesting to note that here, and occasionally elsewhere in his nude studies, the artist included body hair; in art body hair was traditionally reserved for men, as it was associated with sexual aggression and virility which women were not supposed to have. A moral overtone to this attitude was added in the nineteenth century, when it was considered unseemly to portray body hair on women. Courbet's vigorous women, even the coy nymph in *Woman in the Waves*, were sufficiently earthy to retain such elements of their personal accessories.

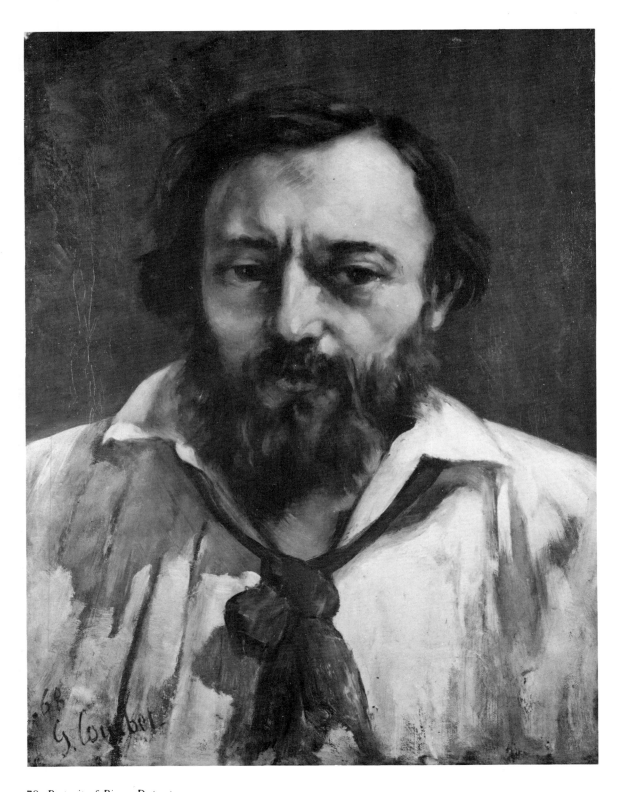

70 *Portrait of Pierre Dupont*
KARLSRUHE, Staatliche Kunsthalle. Signed and dated lower left: 68 G. Courbet. 52 × 40 cm.

Pierre Dupont was one of the worker-poets of 1848, whom Courbet must have met soon after his arrival in Paris; Dupont belonged to the group of intellectuals and socialists, including Baudelaire, with whom Courbet had spent his time.

71 *Copy of a Self-portrait by Rembrandt*
BESANÇON, Musée des Beaux-Arts. Signed and dated lower left: 69 G. Courbet; annotated lower right: Copie Mée Munich. 87 × 73 cm.

During the summer of 1869 Courbet visited Munich with his friend of twenty years' standing, the artist-philosopher Paul Chenevard; while there Courbet made three copies of works at the International Exhibition, including this work and the copy of Hals's *Malle Babbe*, (Plate 72). The Rembrandt painting, now known to be an excellent, old copy by an unknown artist, is still in Munich, at the Alte Pinakothek; Courbet's copy, as Clark suggests, represents the first time the painter had been able to use Rembrandt as a basis and produce something essentially his own.

72 *Copy of 'Malle Babbe, the Witch of Haarlem' by Frans Hals*
HAMBURG, Kunsthalle. Signed and dated lower left: 69 G. Courbet; annotated lower right: Aix-la-Chapelle; and centre right: F.H. 1645. 85 × 71 cm.

Copied by Courbet when it was on exhibition in Munich, this painting shows the artist's sense of loyalty to and appreciation of the artists of the north; Hals's technique was an inspiration to Courbet from 1846.

73 *The Cliffs at Etretat* (*La Roche Percée*), detail of Plate XII

This detail of the late addition, the little sailing boat to the right of the composition, shows the heavy dry paint underneath the light fluid brushwork of the vessel and also provides an excellent example of the delicacy of the artist's knife technique, here creating the foaming edge of the surf.

74 *The Beggar's Alms (Ornans)*
GLASGOW, Glasgow Art Gallery, Burrell Collection. Signed and dated lower left: 68 Gustave
Courbet. 210·8 × 175·3 cm.

One of Courbet's few later works with a socially conscious theme, *The Beggar's Alms* took up the
subject of charity which he had explored much earlier in his *Young Ladies of the Village* (Plates III
and 28). In the early work the subject depicts charity from women of the rural bourgeoisie towards
a peasant girl, while in this composition the treatment of the theme was more anecdotal, dealing
with the poor giving to the poor. It was almost universally unpopular at the Salon of 1868, decried
for its ugliness and woodenness.

75 *Still-life with Apples*
THE HAGUE, Rijksmuseum Mesdag. 1871–72. Signed and dated lower left: 71 G. Courbet; inscribed
lower right: Ste Pélagie. 59 × 73 cm.

During Courbet's imprisonment in Sainte-Pélagie in late 1871, he was allowed no human models
and had to rely on friends and relatives bringing him fruit and flowers to work on as still-lifes.
Although many were signed 1871 and inscribed Sainte-Pélagie, the artist often did this to advertise
his imprisonment; he spent the first months of 1872 as a prisoner on parole in the clinic of Dr.
Duval at Neuilly, and many of the still-lifes were in fact painted during that time. This superb
still-life, like several of the period, shows enormous fruit set beside a tree in a landscape, with a
strange and powerful sense of majesty caused by the unexpected proportions of the picture's
components. Courbet also painted several pure landscapes and seascapes from memory during this
time (Plate 77).

76 *Still-life with Apples and Pomegranate*
LONDON, National Gallery. 1871–72. Signed and dated lower right: G. Courbet 71. 44·5 × 61 cm.

As with his many other still-lifes, it is not clear whether Courbet painted this picture in late 1871 or 1872, despite its dating. Courbet was an expert still-life painter, though he painted them usually only as parts of a large figure composition, for instance in *After Dinner* (Plate 17). While the complex contents of this still-life link it to the eighteenth-century tradition of Chardin, its technique and execution are distinctively personal to Courbet. Davies notes that this canvas was cut, probably from a larger, previously executed picture, and some paint from this earlier study was turned over the stretcher, including the top of a plate. X-rays and other means have revealed most of the rest of the plate under the upper part of the background of this still-life. He also notes that there may once have been one or more extra apples in the foreground of the surviving composition.

77 *The Sea*
CAEN, Musée des Beaux-Arts. 1872. Signed lower left: G. Courbet. 38 × 45·5 cm.

Courbet painted seven seascapes from memory whilst in captivity, of which this is one; it evokes the Channel coast, in Normandy, which Courbet regularly visited.

78 *The Trout*
ZURICH, Kunsthaus. 1872. Signed, dated and annotated lower left: 71 G. Courbet In vinculis faciebat. 52·5 × 87 cm.

In July 1872 Courbet was on a visit to the Ordinaire family, who caught the fish which Courbet used in this still-life. Linda Nochlin (*Realism*) sees it as an image of death, the hooked, expiring trout unable to escape his fate: 'The moment between life and death, the sensation of dying rather than the meaning of death, as the subject of a work of art, is found in its most distilled, prosaic and poignant form in Courbet's *Trout* where the animal is suspended between hook and stream, presented in all his scaly concreteness in the tightly restricted framework of compressed pictorial space, on the pebbly beach speckled with its blood.' Courbet achieved similar ends with some of his dying stag compositions.

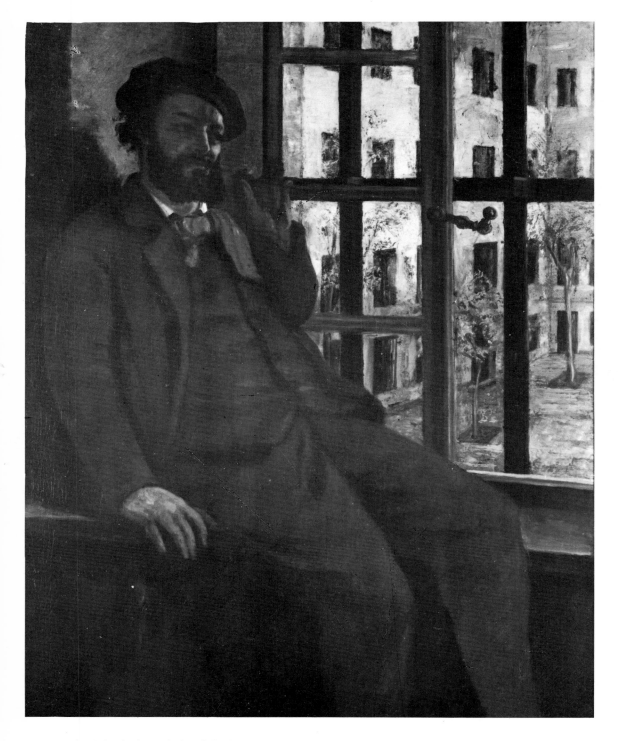

79 *Portrait of the Artist at Sainte-Pélagie*
ORNANS, Musée Gustave Courbet. 1873–74? Unsigned. 92 × 72 cm.

This portrait has little similarity to the conditions and environment in which Courbet was imprisoned, but was intended as a reminder, softened down, of that hard and painful time. The man here is a younger version of the artist. Courbet had indeed lost some of his vast weight and paunch during imprisonment, but his hair, as can be seen from contemporary photographs, was by this time grey, not black; by the date of his exile it had turned white. De Forges suggests that this work should be ascribed to the period of Courbet's Swiss exile and not c. 1872 as usually thought. It is a deeply sad and despondent image, summing up the depression and disillusionment of the artist's final years.

80 *Sunset on Lake Geneva*
VEVEY, Musée Jenisch. Signed and dated lower right: G. Courbet 74. 65 × 55 cm.

The view is from Bon-Port, from Courbet's final home in exile at Tour de Pelitz; on the far shore of Lake Geneva was forbidden territory, France. In order to survive, Courbet and his assistants produced numerous such popular tourist views of this picturesque country, many of them of very dubious quality.

81 *The Château of Chillon*
ORNANS, Musée Gustave Courbet. 1874. Signed lower right: G. Courbet. 86 × 100 cm.

Scharf has shown that this painting was among those which Courbet is known to have executed with the aid of a photograph; Courbet's home in Switzerland was only a few miles from the château, and he painted many variants showing different views of it.